Short Form Improv

Short Form Improv

Techniques and Philosophies

By Jack Reda

Table of Contents

Introduction

How Long is Short Form?

Much of the improv "world" is divided into those that prefer long form improvisation, and consider it a challenging art form, and those that like the fast-paced comedy of short form.

This is a gross generalization, but then most "normal" people still don't really have a clear idea what improv is. I blame The Improv. You know, the string of comedy clubs that launch many the career of a stand-up comic. Improv, for those of you not in the "know" is NOT stand-up. They are two very different forms of performance art. Someone like Dr. Phil might say "Improv, stand-up, what's the difference?" To that I would ask "Psychiatry, psychology, what's the difference?" To an outsider, both cases have more in common than otherwise- but the differences are notable.

Improv, if you hadn't guessed it by now, is improvised. That is, there's no script or prepared material (or in the case of stand-up material, tested over and over before countless audiences until a joke is reduced to its essentials and can be delivered in a drunken stupor if necessary, and quite possibly is necessary). Improv is genuinely spontaneous, whereas stand-up comedy need only appear so.

Not that I am knocking stand-ups. Au contraire. I love good stand-up, and enjoy mediocre stand-up as well. It's a tough form of comedy, made more so by the trend of some stand-ups to verbally assault members of the audience (especially those foolish enough to sit in the front row).

Because almost everyone has heard of The Improv, and knows it means stand-up comedy, the meaning of "improv" gets muddled for some people. You can see it when audiences at an improv show refuse to sit in the front row. Clearly they're worried about a verbal assault. However, that's rarely the case in improv. Rather than mock and ridicule the audience, improvisers tend more to try and include the audience, relate to them, involve their input. Of course, we sometimes do mock them. But not until we've lulled them into a false sense of security. Then they often don't even notice they're being ridiculed. That's the best time!

This brings us to the two basic forms of improv: short form and long form. As you might suspect, there are really many more forms of improv than just two, but for purposes of simplicity let's pretend there are only the two. And while we're at it, let's pretend that all long form is the same (since this book is really about short form). We're going to pretend that long form is pretty much one scene that goes on and on and on, for the entire show, and when the scene finally ends, the show, mercifully, ends too.

Short form, therefore, is any form of improv that consists of at least two, completely separate and unrelated scenes (or games) presented in the course of a single performance. In reality, it's way more complicated than that, but it's just too much to address in one book. Maybe I'll work on another one down the road called "other non-long-form forms of improv than just short form" (or something with a snappier title).

Now that we've endowed short form so indiscriminately (time wise), you might wonder "Is a ten second scene still considered short form?" Yes, it is. Who knows if a scene that short is any good, but it certainly can be mere seconds long. You might also wonder "Is short form improv always comedy?" Certainly not. There are groups that perform serious short form, and there are probably audiences that watch it (and even enjoy it). However, most improv in general is comedy (short and long form alike). I think most people will agree that being spontaneously funny is probably harder than being spontaneously serious (yes, there are plenty of jackasses who can't be serious for any reason, but let us not concern ourselves with them). Therefore, we're going to also pretend that short form improv is supposed to be of a comedic nature.

So... short form improv is: scenes (or games) that run anywhere from a couple of seconds to generally under an hour, and are designed to make audiences laugh. With the exception of events like "24 hour improv telethon", however, your typical short form scenes will run in the five to ten minute range.[1]

[1] These definitions of short form and long form aren't accurate by a long *shot*. Actual long form can also consist of multiple scenes and games, and can run any length of time, even ten minutes. Thus, these aren't definitions so much as they are my saying "let's move on".

What's so special about short form anyway? Well, compared to long form, not much. Both can be fabulously entertaining. Short form tends to be faster paced, but that isn't universally true. In fact, just about everything in this book can be applied to long form work, when you get right down to it.

The one advantage long form may have over short form is time. With long form, you may have more time to establish everything for your scene work. That doesn't make long form any easier. If anything, consistently good (and funny) long form can be much harder because you have to be able to sustain everything you're doing. Plus, many long form structures are quite complicated (for performers and audiences alike).

Therefore, if you're easing into this whole improv thing, you may be better served with honing your skills on short form. Once you can deliver concise, witty, tight, clear scenes that last five to ten minutes, it will be so much easier to extend those stories to twenty, thirty, or fifty minutes. The bottom line, of course, is providing an entertaining experience for an audience. Having a good time helps… and you'll enjoy improv more when you feel like it's good.

Jack Reda
April 2005

10

1

Foundations of a Scene

If you can establish the setting, characters, relationships, and/or plot in two lines of dialogue, imagine how much time you then have for your scene to unfold. Many improv games employ a structure that doesn't properly allow performers to develop their characters and relationships. The more you have to go on from the beginning, the easier it will be for the "gimmick" to work.

Many improvisers start to form the plot to a scene, the moment they take the stage. They may not be aware of it, but on some level an idea is forming, and they pursue that idea. Every person who enters a scene has their own idea about what is going on, where the scene is taking place, etc.

Odds are, no two people are having the exact same idea.

So, what can often happen is two people performing a scene are actually performing two different scenes at the same time. They have some elements in common, but only those that they have shared with everyone who's paying attention. Whatever is going on in their minds is completely unknown to their partner. At some point, one of them will say or do something that is incongruous with their partner's scene.

One of two things happen at that point; they either quickly go with it, adapt, conquer. Or, they stumble. Hesitate. Wonder, "What the heck was that?"

This happens when people are reluctant to say or do something bold and definitive. We worry about denial. Too much, sometimes. We fear our offer will contradict something that the other person has been establishing.

The thing is, you can't contradict what you don't know. If the other person hasn't actually shared some specifics with you (and the audience), then how can you know if your offer is congruous or not? You just can't.

Improvised scenes are like puzzles. At the end of a good scene, you've created a beautiful picture. Wow, it's a dog running through a field. And butterflies. Very nice.

At the beginning of the scene, though, you have no idea what the puzzle will create. Every offer you make is a piece of that puzzle. The first few offers probably won't reveal very much of the picture. But with each connecting piece, the picture becomes more and more clear. Before long, it will be easy for the performers to see where it's heading.

The danger is when you add in pieces from a different puzzle. This happens a lot in improv. "Look at me, I just made a wacky offer, which has no clear relation to the scene in progress." Don't be that guy. He's kind of a jerk.

Once a performer makes an offer, let your offer connect in some way. Let it be apparent that your piece is from the same puzzle.

We hear a lot about the concept of "Yes, and"; it's not just about accepting offers. It's about enhancing and supporting. You acknowledge the other person's offer, and you make your next offer a connecting piece.

This brings us to the scene's foundations. These are the elements that are important to identify in order to have a successful scene.

- Setting
- Characters
- Relationships
- Plot

There is no required order for establishing these elements. Some are easier than others to do at the very start of the scene, but any one of them can be contained in your very first offers.

The habit of many performers is to start by establishing an environment. This is most often done through mime. We do mime in this manner, mainly

because having a character alone in a scene, talking to himself, will probably seem contrived.

"Here I am, at the hospital, where I am Chief of Surgery, and have been for eleven years."

That's lame. So, instead of these informative monologues, we usually enter the environment and silently work in the space. With mime.

Here's the thing about mime: everyone does everything differently. What may look like *preparing an operating room* to you will possibly look like *baking muffins* to someone else.

This is not to say that mime isn't important. It can be vitally so. Miming activities in improv is not only extremely important in creating a reality in your scenes (despite being a concrete example of the "lack of reality") it is also a great opportunity for comedy. More on that later.

So, when someone starts a scene with mime, and that person's partners aren't really sure what they're seeing, they face two potential problems: One, they'll make lukewarm offers, not really establishing anything, for fear of "denying". Two, they will make a bold offer that does indeed deny something that was established (perhaps something the audience *was* able to pick up on, or simply throwing the first person off completely with this seemingly "left-field" offer).

So complicated, and unnecessarily so.

This is why I'm a big advocate of starting scenes with two people. Conversation in these cases is not contrived, and so many more clues can be given with a combination of dialogue *and* mime.

One person can certainly establish a setting. I'm not suggesting it can't be done. I think, however, it can be a lot less ambiguous more often than not when two people start a scene together. One person can also establish a character. This is such a wide-open area of improv (and another I'll talk about later), that even the way you stand can suggest your character. One person can also establish plot points. The one thing a performer alone can't establish is relationship.

Relationships are extremely important. Even two strangers in a scene constitute a relationship. Plus, it will be easier for the performers to conduct the scene when they all know the characters are indeed strangers. When only one proceeds as if the characters actually know each other, their scene can become muddled.

Muddling is something that is better avoided in improv. The way to reduce muddling is with clear offers- offers that have definitive qualities to them.

"Hey Dad" is a very short, but very *clear* offer. And, it's a relationship offer. The two characters are related, and one if the dad. See how that differs from an offer of "Hey", or even "Hey John"? The "Hey John" is also a relationship offer, but not as clear as "Hey Dad."

So many times I've seen scenes that go like this: Joe starts the scene by miming an environment. It's really elaborate mime, but the audience and the other players aren't exactly sure what all is being mimed. Tony enters the scene, and says "Hey, how's it going?" Of course, Tony would love to make an offer that has value, but he's also afraid to say something too specific, in case that isn't where Joe was going. Joe, meanwhile, isn't sure what Tony's character is, and isn't sure if Tony thinks their characters know each other, so he responds with an equally empty "Not bad, not bad."

The scene goes on like this for some time. Eventually someone says or does something that gives everyone something to go on. Usually. Sometimes the scene goes nowhere slow. The whole thing about short form is that it's short. The scenes aren't meant to last very long, and here you are spending a lot of time wondering who the other guy is, and whether you know him. This is when assumptions bite you in the buttocks.

As I mentioned earlier, people tend to form ideas in their head about the scene (and all of the foundation elements). After awhile, they begin to assume they have established some or all of these elements. Their partners haven't got a clue what the first person thinks they've established. Chaos ensues.

This can all be avoided by starting the scene with some dialogue containing clear, useful offers.

14

EXERCISE : "Two Lines"

Two performers take the stage. Each says a single sentence (makes a single offer). See what can be established in only two lines of dialogue. Whoever speaks first needs to say something that establishes any of the four main elements of scene work (Character, Setting, Relationship, Plot). The other performer needs to figure out what *hasn't* been established yet, and try to offer something with their response. You want to avoid saying something that sounds too contrived (like "Here we are in the Amazon", or "Well, you are I are both doctors, aren't we?").

EXERCISE : "Leader / Follower"

Do some two-person scenes. Player One must establish everything: setting, characters, relationship, plot. Player Two isn't allowed to establish anything. Once Player One establishes something, Player Two must accept and support it. Player Two should refrain from embellishing anything that Player One could likewise do. Performers need to be able to be Leaders in some scenes, Followers in others. Ideally they'll need to be both in most scenes. This exercise is supposed to help you identify what is involved and necessary to do to play both roles, but it's also fun to lollygag as Player Two and see how long it takes to get an endowment you need.

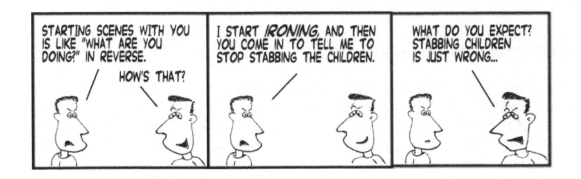

16

2

Character VS Situation

Be willing to give up your idea. You will make strong (even brilliant) offers, which will be denied, forgotten, or misunderstood. It's better to just let them go than to fight to keep them in. Give the other performers' offers the attention and support you wanted for yours.

One thing I noticed about many short form troupes was that they were made up of people who approached improv from one of two basic methods: character-based improv, and situation-based improv.

The character people would enter a scene with a specific kind of character, regardless of the suggestion or game. Then they would play that character throughout the scene, exploring how the character would react.

The situation people would play a character that was essentially themselves and respond more to the situation of the scene.

Situation scenes (at least if most of the people in them were also Situational improvisers) tended to be more "realistic". They were normal people in a somewhat extraordinary situation, and dealing with it as rationally as possible.

The Character scenes were a lot more "cartoony" or caricatures of actual people. They were usually more absurd, physical, and involved exotic animals. Not that this is bad. Just a curious observation I made.

I found that in most cases, I tended more toward the Situational improv. That wasn't always the case. In high school, and early in college, I was definitely a cartoon every time I did improv. I was always an outrageous character, who was invented the second I stepped on stage, regardless of what may have already been going on. That changed about halfway into my college

acting class. We'd begun improvising scenes, to work on certain acting skills and techniques. My teacher quickly broke me of my cartoonish tendencies. In acting class, we were trying to portray real people in real situations (and consequently, we weren't going for laughs).

For some time after that, I was constantly in the same groove of trying to be as real as possible. It wasn't until about ten years later, as I was doing ComedySportz for the first time that I allowed the zanier characterizations to creep back in. But even then, most of the time I was pretty much playing myself, and just reacting.

Every once in a while, a scene is clearly half character and half situation, and it is quite evident that the two halves are not meshing. This causes the audience to be unsure of how to respond. They don't know what level of "reality" established in the scene is the "normal" one. This is not to say that audiences have a hard time watching a scene with a clearly ridiculous or far-fetched level of reality. On the contrary, they enjoy it as much as any other kind of scene. But they want some kind of consistency.

When a scene has gone on for two minutes in the "real" world (perhaps a scene about junior's report card, and whether or not the parents will let him go to the fair), that suddenly involves ninja leprechauns who have taken the cat hostage, it is disconcerting, at the very least. It might still be very funny, but chances are two separate scenes focusing on one aspect or the other would probably be better.

Nevertheless, this is how some improvisers work. They are usually entering a scene from the perspective of what is a logical course of action (but still funny, in most cases), or they enter with possible ways to energize the action, or raise the stakes immediately. If I enter a scene as a ninja leprechaun from the very beginning of the scene, it should set a pretty clear precedent for the entire scene. But if people have established a relatively realistic setting for their scene, it's probably inappropriate for me to enter as the little McNinja. Probably.

Does this mean a scene that starts with a ninja leprechaun can't be about a more mundane plot? Absolutely not. In fact, many Character based scene are just that; "Fish out of water" scenes. The ninja leprechaun tries to get a loan for a house. Or he wants to adopt a South American baby. Or he

18

needs to see a dental hygienist. These are usually very funny scenes, which often require little work to make them funny.

I know that this seems more like a better definition for "situational" improv. And maybe what I call situational should be called "realism" improv. But I'm stuck in my ways, so there it is.

A better reason is that in many scenes, the Character is not in a situation at all. It's just a collection of wacky characters, and how they relate to each other. The plot is secondary (if there is one at all). You can certainly get a lot of mileage out of a couple of very funny characters having a discussion (or exploring silent tension... we did a scene once that went without dialogue for more than two minutes, that involved an impatient hunchback and an uptight high status character, simply reacting to each other in their environment... it was very funny, and had no plot to speak of).

As for the Situational improv; those are rarely without a plot. Plot is almost the strongest element, since the players are in essence playing themselves. It's almost never just Jack and Bob having a conversation with nothing else going on. That might be entertaining, but on some level, we imagine it probably wouldn't be, so there's something that happens. A situation arises.

Some people enter or start a scene neutrally, and wait for some other impetus to dictate their character. They get endowed by another player, or respond to something someone says. Until that moment, the audience knew nothing about their character, and couldn't have guessed what they would be like. Some players wait offstage for that evolution, and enter as the character that has been created by whatever is occurring onstage. This is sometimes a nice hybrid of the two styles, but more often than not leans more toward character-based improv. Jill Bernard of Minneapolis is good at this sort of thing. She may decide on a character before the scene begins, but I suspect more often she decides on a simple trait, and lets the character evolve from there (a way to walk, or an emotion). She will often enter a scene in progress with a character that logically fits in, or if she was already in a scene, but hasn't spoken, she will contrast whoever spoke first (retaining the initial element; a physical trait, or a temperament).

One could argue that a possible disadvantage of character improv is that the same (or darn similar) characters will pop up. To a new audience, it's just a

brilliant character. To repeat audiences, and the rest of your troupe, it will be a stock character. I have no problem with stock characters. It's sometimes even fine to rattle off a few stock bits that character has done and said before. But at time point it ceases to be improv. Just something to think about.

EXERCISE : "Mr. So and So"

Perform a scene where you must endow each other with character traits. Whenever a player enters the scene, someone already in the scene will immediately endow them. "Good to see you, Mr. Obnoxious." "I see Ms. Irish Accent has arrived." "Thanks for coming, Mr. Throws Himself Around." Vary the types of endowments (verbal, physical, emotional, etc.) Players can leave and return as a new character.

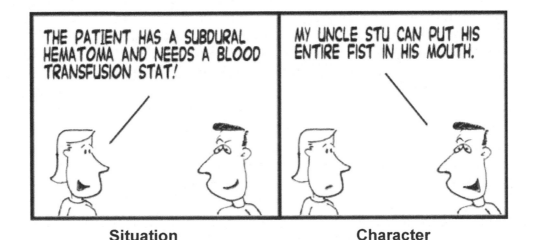

Situation **Character**

3

Objectives

Scenes about mundane people in mundane situations, carrying on mundane conversations will only get you so far. Either someone has to happen, or someone has to want something.

A lot of scenes are like office parties. I don't mean they're about office parties. What I mean is they seem to involve people showing up, one at a time, casually. No character is particularly excited to be there (sure it's a party, but these are your co-workers, not your friends). They enter with their scene offer, like a potluck dinner (here it is, if you want any). They're in the scene, because they have to be there (not because they want to be there). The characters are neutral and inoffensive (don't want to do anything foolish, in case the boss is watching). The whole scene has this dull atmosphere until someone brings in an offer with chutzpah.

One way to get around this tentative climate at the beginning of many scenes is to start things off with an objective for your character. This is a mission for your character in the scene. It can be vague, or very specific (indeed, it can get more specific as the scene parameters get more specific). Some objectives will have to change immediately (or may have to be outright abandoned) as the scene unfolds, simply because someone else's offers (or interpretations of your offers) take things in new directions.

Here are a few simple objectives:

-I will be taken seriously
-I want to take out my frustrations
-I am going to seduce you
-I want out of this relationship/situation/room
-I must get help fighting this urge to kill

No matter what is occurring in the scene, the objective is coloring your actions, reactions, and intentions. Most objectives can be applied to any situation you find yourself in when doing a scene.

Imagine you're in a scene about an actual office party, and you've decided to have the objective "I will be taken seriously". As you begin the scene, you've created a history that you perceive everyone perceiving you as low status, unreliable, and/or worthless. It's important to know that this is your character's perception, and it may not be how the other characters actually perceive your character.

Immediately, you have concrete direction for your character in the scene, regardless of what offers the others make in getting things going.

"How's it going, Steve?" (Innocuous first offer of someone else)
"Oh, so you do know my name." (Your first response, using your objective)

I think this response is infinitely more interesting than a simple "Fine, how are you?" response that many people would naturally make.

The reason we're so apt to respond that way, especially in the first five seconds of a scene is because, one, it's a normal response (something we'd actually probably say in real life, and reacting this way is instinctive); Two, because this early in the scene we don't really know much of anything about the characters (the others, and even our own in many cases). We're so used to unraveling the details of a scene piece by piece, over time. Three, because it's safer. Bold offers are scary to make sometimes, especially when there's no real reason to make them (no reason, because there's no context). Objective gives you context.

Even if early in a scene, your objective is essentially met, it's still a great starting point, simply because it assumes a history for your character. With that history in mind, you can probably adjust your objective, or set a new one, if necessary.

Objectives aren't meant to take the place of a plot for the scene. They can evolve into a plot, or parallel one. Mainly, the objective is a character choice (one that is as much about the character's direction as its make-up).

Something in the same field as objective are secrets (things your character doesn't want the other characters to know). Giving your character a secret will give you motivation in what you say and do in a scene. The secret doesn't even have to come out in the scene, but in effect living with a secret gives your character certain traits, stumbling blocks, and paths through a scene.

Here are a few simple secrets:

-I detest all of you
-I am constantly aroused
-I have two weeks to live
-I have to pee very badly
-I am having an affair with your spouse

While it's likely that nothing of your secret will ever materialize, it does give you something to bring to a scene, and the way you present your character's efforts to keep the secret hidden can itself develop into a compelling scene hook.

4

Relationship

You want to play a character that's "crazy", that's up to you. But remember, crazy people can still know the other people they're talking to. Maybe they just think they're someone else.

Two characters in a scene either know each other, or they don't. There *is* also a rare third possibility: When you know someone who doesn't know you. This sort of relationship is most common when one character is famous (or infamous).

For the most part, characters in a scene are friends, relatives, co-workers, acquaintances, or strangers.

It's important for performers to agree on the nature of their characters' relationship early on. Once you know you're both strangers, it makes some decisions easier to make. This is even more useful if the characters know each other. People who know each other have some sort of history together. A history can give you a lot to work with.

Through your improv, you can determine what kind of history your characters have... a sordid one, a meaningful one, a tempestuous one. Discovering your history will provide some direction in your present.

When you have established a clear relationship between two characters, it also helps other players to decide how their own characters fit in. When two people establish themselves as characters having an affair with each other, the obvious offer here for someone else is to enter as a spouse of one of the first two characters[2].

[2] Sometimes avoiding the obvious choice can make for the funniest scene. The Jealous Husband is the most obvious choice in the above example. But what if you enter as the child of one of the

A particularly useful tool for relationships is status (whether your characters know each other or not). Knowing the status between your characters will give clearer directions on what (and how) to say and do.

A typical example of a status relationship is Boss/Employee. In most cases, the Boss is the high status person, and the Employee is low status. This translates to the Boss character acting more high and mighty, and the Employee being more deferential. Endowing a fellow performer with a status gives them immediate material to work with.

Of course, you can have a Boss/Employee relationship where the status is reversed. Suppose the Employee has photographs of the Boss and his secretary in a compromising position. Now maybe the Employee is in a position to make demands. The Employee's status goes up, and it tells the performers how to behave. Having your character's status changed by the actions of other characters often makes for very compelling scene work.

Status isn't limited to human characters. You can have a scene in a silverware drawer, where everyone talks down to the Salad Fork.

Another fascinating element of status is something called Projected Status. This is when your character is clearly trying to project a certain status, but something is preventing it from happening. When your character is the CEO, but he has toilet paper stuck to his shoe (projecting high status, but no one can take him seriously with the toilet paper). A king that dresses as a commoner is high status trying to project low status. Here the Projected Status can become the whole plot.

Location can have status as well. Places like a church or The White House will have high status, and how your character behaves will be affected. The Town Dump or a Parking Lot can have low status. A place like the Nerd Headquarters Gaming Parlor will have high status to a game geek character, but low status to a snobby millionaire character. Recognizing a status opportunity will give you clearer choices in your improv.

characters, catching Mom in the act? This can be a very interesting beat in the scene, and it is still based on the first relationship established.

EXERCISE : "Cards On Our Heads"

Players randomly draw playing cards from a deck, and tape them to their foreheads without looking at them. Then perform a scene, where your character's status is determined by the value of their card. Players won't know their own card, and will have to figure it out by how others endow them. For added fun, treat Aces as being either highest or lowest, and see how that changes things.

5

Emotion

Adding emotion is like putting air in a balloon.

The most overlooked tool in your big box of improv tools is emotion. We all have a pile of stock characters we can do at any given moment. We know how to accept offers and "Yes and". We can establish setting, develop relationships, offer plot hooks, yada yada yada. But emotionally we're usually pretty neutral.

Emotion is a great initial offer. It forces you to deal with something (or make a clear offer to not deal with it, which in itself is telling). It's also a great way to react unexpectedly.

Performer One enters the scene. "Honey, I'm home." Performer Two starts to cry, "Why? God in Heaven, why?"

Performer One probably wasn't expecting that (and certainly the audience wasn't). Sometimes handing your partner the unexpected is the nicest thing you can do in improv.

The reaction we typically get to "Honey, I'm home" is something like "Hi, how was work?" Snore. We talk about building scenes, and how offers are like setting a brick down. Every performer stacking his or her brick, one at a time, until before you there stands a brick edifice of improv. "Hi, how was work?" isn't a brick. It's a return volley in a match of ping pong. Boo! Don't pussyfoot around. Give us an offer that has meat on it. Better yet, give us some emotion.

Emotion can turn "Hi, how was work?" into an extremely useful offer. Sorrow, sarcasm, anger, giddiness... any of those turns that innocuous reply into a mystery that demands investigation. Heck, you don't even have to

know why you're responding with the emotion. That can unfold during the scene. An emotion is less to think about in the heat of the improv, but it can produce bigger results than a tentative response.

The truth is, we sometimes don't have any idea what we're going to do in a scene when it starts. You try to get things moving, and look for offers to support, and organically develop what comes up. But it can take a long time to get to some place interesting. Time is a luxury we usually don't have in short form. Emotion gets you on the bus in a hurry, and down the road. The audience can't wait to see where you go from here.

EXERCISE : "Emotional Meeting"

Get four performers to sit in a line. They're going to conduct a meeting about a random topic. The first and third performer will be "pro", or for whatever the topic is. The other two are against it. Starting with the first performer, talk in turn down the line, arguing the pros and cons of the topic (when the second person starts talking, the first must stop, and on down the line). After you've done this for awhile, do it again, but assign an emotion to each performer (active, contrasting emotions). See how the meeting changes with specific emotions involved, and determine if having the emotion gave you another dimension to play with in the exercise.

6

Hooks

Some short form is too short for a plot, per se. You just need some interesting or silly premise to follow around for a few minutes.

Plot, in its traditional sense, can sometimes take a backseat in short form improv. When you're doing a scene that's only going to be, say four minutes long, you don't have much time to create classic story structure.

If you're playing an interesting and compelling character, there often doesn't even need to be a plot. Nevertheless, the scene is still *about* something, isn't it?

I sometimes play a character I call "Nozmo", who's sort of a strange bird. Nozmo scenes don't have much plot... "Nozmo at the dentist's office" can easily fill four minutes, but what's the plot? Well, the plot is about this odd guy named Nozmo, and he goes to the dentist. Tada!

In order to do these sorts of scenes, I look for something called a "hook". In some ways the hook *is* the plot. It can also be a plot point. And, it can be simply a direction to take a scene at any given moment.

With the time constraints that often accompany short form, it becomes important to identify scene hooks as early as possible. This way, you can embark on your scene without spending a lot of time wondering what the plot will be.

Plot is often hard to spot at the beginning of a scene anyway. Take a movie like *The Crying Game*[3]. What would you say the plot of that movie was ten

[3] She's a dude.

minutes into it? Even twenty minutes in, the full plot is scarcely revealed. On a smaller scale, the same is true of improv.

Most improv scenes follow a zig zag course, story wise. A simple tangent can take over an entire scene. What started out as a scene about firefighters waiting for an emergency call can turn into a romance between sub atomic particles inside a nuclear warhead[4].

That's why hooks aren't so much a plot as they are a stepping stone (on a path that could ultimately be the plot).

The hook is something that demands some attention. It's often an unspoken "why" that the audience and performers subconsciously are asking themselves after an unusual offer (or not so subconsciously).

> "You feeling all right, Dan?"

> "Yeah, I'll be okay. Rough night with the burrito masseuse."

There's an obvious hook offer here. But there's also a less obvious one. The very first offer is a possible hook, depending on how you want to respond. Despite opening things up with a question (see Questions), the first person has established a relationship of familiarity, and endowed the other person as likely not feeling all right.

> "You feeling all right, Dan?"

> "Yeah. Let's get those muffins on the truck."

Here, the second person may not be biting at the first offer, and if the first person lets it go, they'll have to work on another scene hook. But I think there's a ton of scenes waiting to happen here, if you treat this initial offer as important.

> "You feeling all right, Dan?"

> "I don't know what you're talking about."

[4] Courtesy of Bob Garman.

Getting defensive about a seemingly innocent question has created a scene hook. Maybe it wasn't so innocent. And of course, denying that anything's wrong almost certainly means something *is* wrong. You can milk this into a scene with little effort.

"You feeling all right, Dan?"

"I'm dying of monkey leukemia[5]."

One can debate the virtues of an offer like that, but regardless, the second player has take the ball and run with it.

"You feeling all right, Dan?"

"Screw you!"

Kapow! If you can't go anywhere from here, you should quit doing improv now.

The point is, hooks happen all the time, right in front of your improvising face. But you have to be looking for them to see them sometimes.

What can happen is you get a plethora of hooks, and keep accumulating them. And now you have too much crap going on in your scene. The audience wants to know more about the "whys" of all these offers, but you're too busy ricocheting around the scene.

There's something I like to call the "Table of Offers" in improv. Every offer we make in a scene goes on a table in front of us (the audience can see it, but sometimes we forget it's there). Every offer gets tossed onto that table until we really acknowledge it and use it. Tiny details that we sometimes miss because we're not listening close enough to the other performers, or turn away from them for a split second. If someone doesn't make that offer known, it just goes on the table.

[5] Courtesy of Jim Doyle.

After awhile, the audience can barely see the scene, because all the crap on the Table of Offers is metaphorically obstructing it. They get removed from the scene because they're wondering why the performers aren't dealing with some of these offers.

Do yourself a favor. Find a good hook early on, and ride it like a wild buffalo. The hook may not go anywhere, but it will give you some time to find a hook that you can really sink your… uh… hooks into.

7

Environmental Support

Regarding guns... Some performers have a habit of drawing guns in many of their scenes. When this happens, the number of possibilities for your scene can be dramatically reduced. I'm not saying you shouldn't draw a gun... but consider drawing a crossbow. At least it's different. And now you have an opportunity to explain why your character has a crossbow (and not a gun). A lot of times, the gun comes out from a lack of anything better to do in a scene. Also, be aware that being shot by a gun doesn't mean being killed by one. Even a headshot can be "only a wound". This can be good or bad (like everything in improv), so I just say "be aware".

There are two great ways to add environmental support to a scene. The first is adding a touch to help establish a setting. You can become a non-essential characters (what might be considered an extra in a movie). You're there to make the scene easier to discern. If the other players find a need to interact with your "character", you're there to help out. But it should be clear that you don't require it.

Example: A scene in a restaurant. You become a patron at a table in the background, or a busboy who refills water. You may not need to ever speak, but your presence adds to the scene.

This is not limited to human characters. You can be an animal, or even a set piece. You also can add these non-human environmental additions during a scene in progress. When someone refers to something in a scene (that isn't already being represented by something), you can take that as a cue to become that something. Even if it's something that would have already been in the scene (since it wasn't referred to yet, it wasn't important that the audience had no physical representation of it). Certainly you can get away

with never having a physical representation of something (mime is a terrible thing to waste), but if a performer can do it, why not take advantage of it?

Example: During Milwaukee's Kok N' Toast show, two performers were in a scene about cosmetic surgery. Halfway into the scene, they referred to one character's excessive collagen injections. Another player suddenly entered and used his arms to represent the gargantuan lips.

Flavor Text

The second form of environmental support is something I like to call "Flavor Text". This is when a performer enters a scene, not as part of the scene itself, but to point out something to the audience (something that would have been obvious if the scene were really a film, or a full production of a scripted play). The person enters and says something like "We see that the characters are both wearing the same dress." [6]

Details like this can also generally be established within the context of a scene (you say "I can't believe you're wearing the same dress as me"), but if it doesn't occur to the performers already in the scene, another performer would need to enter to establish it.

Sometimes, rather than entering as a character in a scene whose only purpose is to essentially add flavor text, it makes more sense to just point it out as part of a detached reality.

Example: During a DCUP show about a domestic dispute, the "police" were called, and had the house surrounded. The negotiations weren't going well, and to heighten the desperation, a player jumped into the scene with some Flavor Text. He pointed to the "husband" and informed the audience that a red laser-sight dot had appeared on the character's chest. Done in this manner, it was understood by the players and audience that the husband's "character" didn't know the dot was there. It was felt that in the context of the scene, it was going to be better for the husband to not realize that police snipers were about to take him out. One can certainly argue that having the police actually announce they were training their laser-guided rifles on the

[6] Since most short form doesn't involve costumes (or the notion of identical costumes is impractical) this example can't be achieved physically. However, it may be important, or a funny detail for the scene.

husband can be funny too. It's a matter of taste (but it should be known that the Flavor Text offer above got a big laugh, and made for a funny scene overall).

Flavor Text can refer to anything in a scene. It's usually about something that isn't or can't be demonstrably represented, and it often is something the characters don't need and/or want to address specifically.

Examples:

"We see he has toilet paper stuck to his shoe"
"The book is L. Ron Hubbard's Dianetics."
"They are standing in quicksand."
"It starts to rain."
"We see rescue ships and planes in the background."

Flavor Text can be a quick, throwaway joke; an important plot point; a bit of extra setting detail that may or may not be important. Anything is possible. But don't get carried away with using it. Everything in moderation.

EXERCISE : "Scene Painting"

Before a scene technically begins, one or more performers walks on stage and describes an element of the setting to the audience, then leaves. After enough of these elements has been "painted", the scene begins. Performers then use the painted environment as much or as little as they feel necessary, or let the painted elements help to inform their offers.

8

Physical with the Verbal

Show us, don't tell us.

It's amazing to me how many improv scenes devolve into "talking heads". This is where the performers stand around talking to each other, and doing pretty much nothing. Sometimes there are three, four, or five people on stage, all jockeying for position verbally.

This is because most improvisers who are clever and witty tend to get too comfortable with the verbal side of performance. They may also be less likely to play "characters", and more often just play themselves in scenes.

Sometimes we're even afraid to allow silence to occur in our scenes, especially short form. The moment the scene starts, it's "blah blah blah", non-stop until the scene is over. Physicality in improv is an entire component that we often ignore.

Some games in improv almost count on physical aspects. A game like Forward-Reverse can be very enriched by having strong physical offers (and in many ways, it can make doing the game easier to accomplish, giving you a road map of what's occurred in your scene[7]).

We can make offers physically. We can establish things physically. If you start a scene by holding yourself and shivering, you've established a little something. We don't know if you're inside or outside yet, but you've given the scene something specific to address.

[7] However, just as a scene with a lot of talking and very little "doing" can become tiresome, a turbo-charged Forward-Reverse that has the performers running around like weasels for no real reason is just goofy (and not the good kind of goofy… the bad kind).

A lot can be gleaned about a character simply by how you conduct yourself physically. The nature of a relationship can be construed from how the characters conduct themselves physically.

Then there's always the stage picture. Many performers treat the stage as if it's only one foot by two feet (apologies to those of you performing on a stage that size or smaller). Use the whole stage. Depending on your venue, you probably don't even have to limit yourselves to the stage. Your improv can take you right into the audience, and it should.

The "fourth wall" is not as solid in improv as it is in other forms of theater. The interactive nature of improv is one of the things that allows an audience to connect with the performers. They may be a little apprehensive about being engaged, at first. But you have to sometimes remind them that this isn't television.

In 2004 I started a show with Steve Heaton and Matt Hartman called "Boneless Chicken Cabaret". We did scenes and games wearing chicken costumes. We also didn't speak any intelligible dialogue (just gibberish, or clucking). This really forced us to use physical comedy a lot more than usual. It was a very fun and funny perspective for us to explore in improv, and our physical offers took on a lot more importance. Sometimes we had no idea what was really going on in a scene, but usually we had a pretty clear feel for what kind of offers each chicken was making.

Physical comedy is not just clowning around on stage, or pratfalls. You can find laughter in smaller reactions, or even the sudden lack of physicality. Like most things in improv, a little bit can go a long way, and the addition of a physical side to your scenes can change things up in a positive fashion.

EXERCISE : "Silent Tension"

Start a scene with two or three performers, and don't say anything for at least a full minute (go longer if you can). Try to make offers physically to establish things. Create an environment, create relationships, and let the tension build as you refrain from speaking. The idea is not to be playing mutes, or not have the ability to talk. You simply want to see what develops without the aid of verbal endowments.

EXERCISE : "Fence Painting"

Pick some kind of activity to do in a scene, and then don't talk about it. In fact, you aren't ever allowed to mention or refer to any aspect of the activity. You must hold a conversation of some kind, and continue doing the activity. This can do a couple of things for your scene work. One, it allows a scene to take on a more realistic quality. A lot of times in life, we're working or doing something, but we're talking about some other topic or gossip. The other thing this does is to give you some physical focus. You have something you can do in your scene, instead of standing in front of your partner, arms at your side, yammering away in a stage picture that's as boring as a dog's butt.

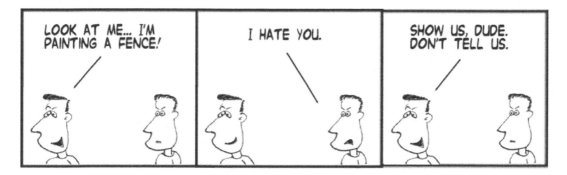

9

Justification

The audience wants to know why. When something bizarre happens in your scene, you have to explain (or at least hint at) why it happened. Otherwise it's just a "Look at Mr. Wacky" moment that destroys the trust you've been trying to create with the audience.

The notion of *justification* manifests itself in two ways in improv. The first is when its presence is required on purpose (that is, you're playing an improv game that is structured on justification, like Parallel Universe). The second is when someone has just screwed up, and now you gotta fix something.

I believe justification is one of the most compelling elements of comedy improv. A lot of improv games revolve around it (games like Blind Line and Freeze), but it's something that will crop up in any improv games.

Mistakes are a great opportunity for justification. If someone has established something in a scene (a detail of setting, someone's name, anything), and it gets forgotten or messed up, you have a chance to justify that mistake. And, in doing so, you make it look like whatever happened was on purpose, and not a mistake after all.

The audience will notice the mistake. If you gloss over it, and pretend it didn't happen, it just looks like you didn't notice it. Then the audience feels like they are picking up more details than you are, and that something is amiss.

I was doing a scene one time, where I'd established a professor character had died. We referred to the professor a couple of times, when suddenly someone came in as the professor. It was immediately clear that the person had just not realized the character was supposed to be dead. You could see wheels spinning in everyone's head about how they were going to justify this

entrance. We almost tripped over each other to do it. I think on the one hand, we were annoyed that the other performer made such a goofy blunder, but another part of us was delighted at the opportunity to justify it.[8]

Denials are another time for justification. If someone negates an offer or element of your scene, you have to make sense of it. It's a challenge, especially if whoever denied you in the first place is liable to do it again (or all the time). But that's really improv at its purest; reacting quickly.

> "Your hair's on fire."
> "No it's not."
> "Ah… it's these new contacts. I keep seeing phantom flames."

If you'd left the "No it's not" hanging there, it just gets awkward. Of course, if that person can justify for himself why his hair's not on fire, then you have no worries. But you have to be ready, in either case.

EXERCISE : "Justified Denials"

You and a partner have a conversation. At every opportunity you must try to deny something the other person says. They must justify your denial in some way. If you say "I'm going to work", they must say "No you aren't, because you lost your job." Now you must justify with something like "No, they just aren't paying me anymore. I still have to go." Try to keep this up as long as you can.

[8] Moments like this are when you can, not only justify someone's mistake, but make fun of them in the process. When you do that, you are pretty much telling the audience that the other guy messed up, but you're going to deal with it. Whether or not you can get away with this depends on you and that guy. Do you get along? Will he try to get you back? Sometimes it's worth the risk.

10

Gimmicks

Most improv "games" have at least one built-in gimmick you can always use. Try not to use it. Take a chance with some new tactics and approaches. That gimmick is still there if you need it.

Anytime you are playing something that's referred to as an improv "game", you are no longer simply doing a scene.

Improv games are generally scenes that have additional qualities, elements, rules, parameters, crazy-crap attached to them. The scene is a framework and the "game" is dropped onto it.

There are plenty of improv games that aren't scenes at all (Dr. Know-it-all, Slow Mo, Advice Panel). However, the one thing almost all of these games have in common is a built-in "gimmick".

This is a bit that almost never fails. It's not necessarily something you or someone else said once in that particular game that got a big laugh, and now you're tempted to say the same thing some every time you play it- although it certainly could be.

The gimmick is more often a form of delivery, or a type of offer that is especially effective in a game.

Here are some examples:

In the game *Foreign Movie*, after a short line of gibberish, you give a long translation (and vice versa).

In *Dr.-Know-it-all,* you have the one word answer.

In *Forward-Reverse,* after repeating a segment of long dialogue in both directions several times in a row, you begin to paraphrase.

In *6 O'clock News*, you enter as the traffic report, swinging a shirt over your head like a helicopter propeller.

In *Sit, Stand, Kneel, Lie* you lose your contact.

Now, this chapter isn't about revealing SECRET GIMMICKS TO ALL IMPROV GAMES. Because that would be asinine.

On the contrary, this chapter is about challenging oneself to not even use those gimmicks. This is because, like the line someone said in a scene that was funny as heck and you'd feel dirty saying it in a different scene the next week, these gimmicks were discovered once (decades ago) in the midst of a scene, when they weren't planned, and doing them now doesn't require much effort.

When all else fails, you can always do the gimmick. It's a cheap laugh (from the perspective of the improv performer), but it's a laugh nevertheless (and when you need one, you might as well get it).

Until that time, however, avoid those gimmicks. You never know when you'll be the one to discover a new gimmick.

Rather than resorting to the gimmick, try staying true to the moment. I know that sounds like so much cockamamie theater crapola, but what I mean is stick to the basics. If you're doing improv, it's because you think you're pretty quick-witted, funny, spontaneous, etc. If you are, then you probably don't need the gimmicks inherent to most improv games. Just go out there and do some good improv. Establish, support, explore. If you're half as good as you think you are (and you're improvising with a troupe of likeminded people who can pull off half-decent improv), you can present a funny and compelling game[9].

[9] If you aren't, just do the gimmicks. And if you don't know the gimmicks, email me at jack@redamedia.com and I will share with you SECRET GIMMICKS TO ALL IMPROV GAMES, ya freaking noob.

11

Absurdism

Don't try to be funny. Let yourself be funny. If you find yourself in a scene thinking about something that would be funny to say or do, then don't do it. The best and funniest moments in improv arise from the surprise. It's reacting truly to what has just happened in a scene. Stay true to the moment, and the comedy will happen.

In our improv, we often say or do things that in real life clearly fall outside of the norm. In fact, anytime we invoke monkeys, Mormons[10], or Jell-O®, odds are pretty good we've strayed into the realm of the absurd.

Absurdism crops up a lot in comedy improv, which in and of itself isn't a problem. But so often it's merely a throwaway line. It's used for a quick laugh, and then subsequently ignored.

When absurdism is brought into a scene, there's two ways to deal with it. The first is to treat it as unremarkable.

"Ferrets are controlling my sister."

"Again?"

We know in real life, ferrets don't control people (no matter what Fox News says). If someone said that ferrets were controlling their sister, it would give you pause. First you'd assume they were kidding. Then you'd assume they were loony.

[10] I'm not suggesting Mormons are abnormal. It's just that for some reason, non-Mormons love to make references to our friends from the Church of the Latter Day Saints. Maybe it's because they're so nice, and they can take the joke. Or maybe it's because the first thing we associate with Mormons is polygamy, which isn't normal, and *is* funny.

Yet in improv, the most natural reaction is to take these things in stride.

Don't get me wrong. An absurdist offer is perfectly valid. I love them. They're funny. But equally valid is a more realistic reaction of amazement, bemusement, befuddlement, and simple, outright flabbergastedness[11].

Reacting to bizarro things as if they're perfectly ordinary is fine, but treating it as weird as it is can work too. And it can be funny.

Consider the following absurdist offer:

> "We can replace your severed arm with an artificial limb, or a miniature Portuguese fisherman."

A lot of improvisers would respond with something like "I don't know. My cousin has a French impressionist for a leg, and he hates it." This works, and can be funny. But in treating the first offer like it's not that unusual you may be truncating the half-life of that offer.

Consider the following exchange that actually took place in a scene when the second performer decided to react more aghast.

> "We can replace your severed arm with an artificial limb, or a miniature Portuguese fisherman."
>
> "What are you, nuts?"
>
> "It's all right, Mr. Jones. I'm board certified to do this procedure, and the fisherman has signed a waiver."
>
> "But it's just preposterous! You're talking about surgically attaching an entire person to my body."
>
> "Our success rate is very high."
>
> "But why in God's name would I want to do this?"

[11] Apparently, not an actual word.

"Think of the possibilities. You lost a limb, but we're replacing it with four limbs. And another mind… albeit a much smaller one."

To me, trying to win over someone who is resisting the absurd element can be just as compelling, if not more so than dismissing absurdism as commonplace.

12

References

A reference to something generally considered non-comedic can be funny (politics, religion, science, current events). A reference to something obviously comedic can mean death to your scene.

When you reference something in a show, it's balancing act, with many factors to calculate before knowing if it's worthwhile. If it's an obscure reference, you need to proceed without waiting for effect, because sometimes it's too obscure, and no one will understand why you're making a big deal out of it. You can Dennis Miller an audience to death fast, if you aren't careful.

A bigger problem though, is when you reference comedy from another place of origin. There aren't many things that can turn an audience against you faster than that, especially in an improv show. One time, in San Jose, we were doing a scene in a speeding cab, and the guy playing the cab driver said "Don't touch the red button", not too long after *Men In Black* came out. It was an obvious reference, and I literally saw dozens of smiling faces in the crowd turn into frowns. One guy even booed. None us would have guessed that was the kind of reaction it would get, but that's what happened.

Even worse was the time I was in a ComedySportz show in DC when a player decided to enter a scene as the Church Lady (Dana Carvey's character from SNL). I think the audience would have thrown rotten vegetables, were any handy. From the perspective of the player, it wasn't really out of context, but something about invoking comedy not directly from your own body of work can make an audience member hostile.

A reference to topical things is also a two-edged sword. When your reference is very apropos, it will fit in nicely. When you are really forcing it in there, it will feel that way to the audience, and it will seem more like you're

trying to think up references rather than letting material evolve from the improv.

Callbacks

Callbacks are a different story altogether. Crowds often love a good callback. However, these can be executed poorly, causing it to backfire, and make you look like you can't manage any worthwhile material of your own.

A callback is when you reference something from a different improv scene. It can be something you said or did, or someone else entirely. Callbacks only work when it's clear that you meant to reference it. When it looks like you're struggling with what to say or do, and you make a callback, the audience is more likely to think you were influenced by an earlier joke or offer (meaning you couldn't tap the reservoir of your imagination, or worse it was empty).

I think some of the best callbacks are references to previous scenes that didn't go over well, or goofy mistakes someone made earlier in the show. We played a game of 5 Things once, where Steve Heaton was trying to guess "potato". His team tried a couple different ways to convey potato using mime and gibberish, but the closest he could guess was "yam". Not bad, but considering how common potatoes are in our entire culture (especially as opposed to yams), it looked like it would be easy to get. And of course, the audience knows exactly what the players were doing for potato clues. To them it seemed obvious.

Later, I was in a scene that was taking place in Ireland, and during a moment where we had some time, I wandered over to the potato garden, and was shocked to learn there weren't any potatoes at all. Just yams.

It was a nice laugh for the audience, which was protracted by the sheepish look on Steve's face as he understood the callback.

Pop Culture

When you reference something from pop culture, it's easy to go with the lowest common denominator. The very nature of pop culture is that someone or something's more recent iteration is fresh in everyone's mind. I remember when Michael Jackson dangled his baby off the balcony. For

several months, that image made its way into a lot of improv I saw (and did), as well, I imagine, in many other troupes across the country.

Some improv games make direct use of pop culture, and often it gets added to our improv from audience suggestions. When the pop culture is not completely spontaneous, I think it's better to not use the most recent element. Doing a dangling baby for a Michael Jackson reference right after it happened is just too easy. Challenge yourself.

If you're playing a "guessing" improv game, like 5 Things, I think you should start with a more obscure reference. If the guesser doesn't pick up on it right away, that's when you go for the more obvious references.

13

Pacing

No matter how poorly a scene is going, you can always say "Meanwhile, somewhere else".

Most short form improv isn't necessarily concerned with complete stories that contain a beginning, middle, and end. You work toward a resolution in a story, but you often don't need to achieve it.

In fact, a lot of short form doesn't even have a traditional beginning either. You can start scenes in the middle of the action. You just have to be creative with how you introduce characters and setting when you start things in the middle.

I would even recommend practicing this as a technique for succinctly introducing characters and relationships.

Ultimately, performers in short form scenes should be creating a rhythm. They're doing one of three things, in a fixed order: Establish. Support. Explore.

That's your simple formula.

Establish – Support – Explore

You establish something when you make an offer that contains useful information (like the setting, or a relationship). Then you and your partners reinforce that offer by acknowledging it, accepting it, embellishing it, and so forth. Finally, you explore the scene within the context of what you have established (and you continue exploring until you realize you need to establish something else). The formula is repeated.

You don't need to spend equal time on each step in the formula (but exploring will probably get the most). Sometimes exploring and supporting are the same thing (and in fact, the line between all three can blur easily at times). An important thing to note is that you can explore something that was established much earlier. Part of the exploration process is recognizing when something wasn't fully explored when it was first established.

People not in a scene yet have an even simpler formula to consider.

What isn't established? What isn't supported?

When they identify something, it can be their catalyst for entering a scene. Upon entering the scene, they can then switch to the other formula.

This brings up an interesting question: **When should I enter a scene?**

That can depend a lot on the type of short form improv you're doing. Some improv games demand entrances, even when the storyline doesn't require it. For simple scene work, there are two approaches.

The first is *Enter a scene when you have something to add*. That relates directly to the second pacing formula mentioned above. It's a pretty straightforward school of thought; if the scene doesn't need something, don't complicate it.

However, the other approach is more organic. *Enter a scene, and see what happens*. In this case, you become a variable. Anything can happen. Life is uncertain, so why shouldn't improv be so? This can lead to some sloppy scene work; it can distract from a storyline in progress; it can confuse the other players and the audience. On the other hand, it can shake things up and allow for beautiful, spontaneous improv. Things can suddenly move in interesting and unexpected directions.

As you might imagine though, the second approach is typically more successful with seasoned performers and groups with strong chemistry. But what the heck… sometimes you gotta take a chance. Just don't be that jerk who enters scenes simply to be in them. No one likes that guy. Okay… the audience likes him, cuz sometimes he's pretty darn funny. But the other performers don't really like him, and eventually they'll stab him.

EXERCISE : "What Just Happened"

Players start a scene reacting to something that has just happened (without identifying what exactly it was). Some things should be awesome; some should be horrifying. Play around with new ways to react, and see where it leads. Eventually all players involved will have to make offers about what happened, until it becomes clear to everyone what it is. Practice doing this exercise without ever saying what happened in the scene, and compare notes afterwards ("I thought Mom was eaten by squirrels". "Oh, well, you see I thought it was spontaneous combustion". "But you did think it was Mom, right?" "Actually I thought it was a Senator.").

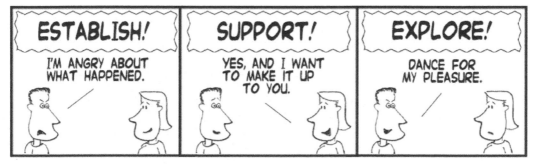

14

Questions

Questions are not the enemy. You can ask a question, and still provide good information. "How are we supposed to learn algebra with bags over our heads?" The audience has learned a lot from that question, and so have the other performers.

Asking a lot of questions in improv scenes is generally frowned upon. This is because you're essentially asking the other person in the scene to make the offers. Questions put the onus on the other person to establish things. "Who are you?" "What are you doing?" "Where are we?"

However, focusing so much on not asking questions makes performers paranoid about it. In the course of a scene, a question naturally occurs to them, but they hesitate.

But why? Oops, that's a question!

Don't worry so much about questions. People ask questions all the time in normal, every day conversations. It's not a big deal. Besides, who says you can't make offers and establish things with a question? Crap, another question.

If the first thing said in a scene is "Dad, how come we always vacation in Ohio?" then a lot of things have been established.

Characters, relationship, setting.

We've also established that a vacation in Ohio is apparently undesirable for at least one of these characters. This can become a plot point.

The reasoning behind this vacation spot can be a scene hook. All these things with one question.

The same question can, of course, be turned into a statement. "Dad, we always vacation in Ohio." But the form of a question makes it more plaintive, and that could be an important detail.

EXERCISE : "Only Questions?"

Players must do a scene where they can only ask questions. No one is allowed to make a statement. If possible, avoid asking the same question more than once. There's two things you want to get out of this exercise... the first is being able to learn how to turn any statement into a question. This is useful because the reverse is true: You can turn any question into a statement. The second thing you'll hopefully pick up on is how it is possible to make offers with questions. It's still possible to establish Setting, Characters, Relationships, and Plot with a question.

15

Musical Improv

You don't have to rhyme in a musical game. It's better to not rhyme at all than it is to come up with a crappy rhyme. Tell a story, move the plot, work the style.

I was never a big fan of musicals. I always preferred to see a play over a musical like *Oklahoma* or *Cats*. I wasn't all that into the movie version of *Grease*, and listening to the soundtrack like my friends were. But, as I got older, I realized that most people, apparently, do like musicals.

I don't know if my aversion to musicals had anything to do with the fact that I can't sing particularly well. Nevertheless, I do like to sing. As I began to learn how to play the guitar, I really got into singing, despite my virtual tone-deafness.

Before I began performing improv, I didn't do all that much singing. By 1996, I was performing ComedySportz pretty regularly, and depending on who was doing sound, the shows would involve quite a bit of singing. I did not excel at those games at that time.

It was clear that musical games could be a real crowd-pleaser. As I said, most people seem to enjoy a musical, and our musical scenes (done even remotely well) always got a terrific response. In judged rounds, it was a no-brainer which game was going to win points, no matter how well the non-musical game went.

I was able to fake my way through the musical games well enough. Most were team-oriented, and I could let someone else take the lead. Background vocals and choreography were no problem, and I focused on that. With games like Da Doo Ron Ron, which are barely musical to begin with, I could manage without much trouble.

The DC team at that time wasn't overly musical (not like the LA team seems to always have been). The DC audiences were satisfied with our predominantly verbal games (we had a small stage, and not too many singers in the group). It wasn't until I moved to California and started playing with San Jose that I decided I needed to really develop my musical skills.

However, there were no clear lessons to learn at our rehearsals. We just dove in and did it, and it was expected we would simply get better. I decided this was not going to work for me, and I had to really figure out *specific* ways for me to get better.

The two biggest hurdles for people in musical improv is not having a good voice, and worrying about rhymes. The first issue matters not a whit. The audience doesn't care if you can sing or not. You're up there making up a song on the spot. That alone makes the audience shudder with appreciation. Being able to do rhymes matters a little bit more, but you should remember that unless an improv game specifically calls for rhyming, you can get away with not doing it at all.

Move the story or plot along in your song.

RHYMING

Of course, people want to rhyme when they sing, because most songs contain rhymes. If you can nail a good rhyme in a song, the crowd will go nuts.

But just rhyming alone wasn't enough. The rhymes had to be good. Too often there would be rhymes that had no connection in the context of the song. The rhyme word was in the song simply because it rhymed.

Formula For Rhymes	
Good Rhyme	Great!
No Rhyme	Good!
Crappy Rhyme	Bad! Boo!

Word Association

The key to having a good rhyme was "word association". If you get a topic like "plumber", and your set up rhyme is "bummer", everyone can tell exactly where you're going. When I knew the topic I was singing about, I would think of something associated with the topic (the first thing you think about when you hear the topic). With a topic like "plumber", you're bound to come up with several different things (pipes, toilet, water, fix, repair, butt-crack, expensive).

The trick was, not to use that association as the set-up. This was a mistake I'd made in the past, and one I'd seen many other people do too. When you used your association as the set-up, then the actual rhyme was usually something unrelated to the topic altogether. This tended to make your song sound meandering. For example, when singing about cheese, a lot of people would find themselves in this cul-de-sac:

When I'm feeling hungry, I like to get some Monterey Jack
It always hits the spot... someone scratch my back.

Note: those exact lyrics have probably never been used (not even by me), but my point is, out of desperation to find a rhyme, people will say anything, and often it makes no sense. The "scratch my back" has nothing to do with the topic of your song, and you may be tempted to use your next verse to justify it. Now your song is really getting off-topic.

However, by swapping places, you can usually force the same pair of words to make more sense. If nothing else, the audience almost never focuses on the setup. All they remember is the rhyme.

When I'm feeling hungry, from my front right to my back
The only thing that hits the spot is some Monterey Jack

Now, while those are not the most brilliant lyrics you'll hear in a song about cheese, for most audiences, it sounds down right ingenious. In any case, it worked for me. I put my energy into thinking of two things quickly: something related to the suggestion for the song, and anything that rhymed with it.

The less obvious your association, the harder it will be for the audience to predict what you're rhyme will be. That's when you really slam them over the head with your brilliant lyrics.

7-5

Realizing I needed the time to come up with a word association and a set up word, is when I stumbled onto the 7-5 technique.

Most people feel compelled to rhyme every line in a pattern of AABB (where the first two lines rhyme with each other, then the next two lines, and so on). This is hard to maintain, and often can result in "lame rhymes". The 7-5 technique employs a rhyming pattern of ABCB (where only the second and fourth, or the "B" lines rhyme). People who study and understand music theory probably know all of this already (as well as the proper terminology for everything). Here's how you break down a single verse into four lines (using an 8 beat count)[12]:

I got a friend named Mary Lou	7 beat line (A)
she likes to sing and dance	5 beat line (B)
I got a friend named Spartacus	7 beat line (C)
he likes to wear my pants	5 beat line (B)

The first and third lines don't rhyme with each other, or any other lines, so they are labeled A and C. The second and fourth lines rhyme with each other, so they share the same label of B. When charting out the lines that rhyme with each other in this fashion, you assign rhyming lines the same letter.

Therefore:

Take me to the ice cream shop
Let me eat until I drop
I don't care just what they say
I'll eat ice cream every day

-is an example of AABB.

[12] The easiest way to identify the 8 beat count, and to know when to start singing is to just quickly say to yourself "five, six, seven, eight" on the beat. You know you gotta go right after the "eight".

64

Here's another way to look at how the typical 7-5 set up works:

I got a friend named Mary Lou	A (This first line sets the story)
she likes to dance and sing	B (The set up for your rhyme)
I asked her to marry me	C (Linking the last lines to the next one)
and gave her a diamond ring	B (Delivering the word association as a rhyme)

As you will see from the example above about "Mary Lou", the first "7 beat line" (the A Line) isn't going to rhyme with anything, and can really be about whatever you want... it's a stall line. It's giving you time to come up with a rhyme for your "word association". The set up for your word association needs to appear on your first "5 beat line" (the first B line). Then you use the second "7 beat line" (C) to prepare for the rhyme. Ergo, the second and fourth lines (the B lines) are the only ones that rhyme. Here you've sung a whole verse, yet it only had one rhyme (but still seems awesome to the audience).[13]

The 7 and the 5 refer to the number of beats in your 8-beat line that you are actually singing (they do not refer to syllables). The A and C lines have you singing for nearly the whole 8 beat count (just one beat to rest), but the B lines give you three beats to think. It isn't a lot of time, but in improv it can make a tremendous difference. If you're able to quickly think of the association and set up before you start singing, the 7-5 technique doesn't become as crucial. But sometimes you need to sing more than once verse. Getting in the habit of breaking your verse into four lines that only contain a single rhyme will help you when you're really forced to think on your feet.

Open Vowels

Another trick I picked up from James Bailey (the manager of the LA ComedySportz) was the use of open vowel words. Words like me, see, you, do, high, dry, though, go, etc. There are so many more words that will rhyme with an open vowel word than most other words, even if you don't have a good association, you can fake your way through a song. You end your 5 lines with an open vowel, and you are usually able to come up with a decent rhyme.

[13] Some examples of real songs that use ABCB: Theme to *Gilligan's Island*, *Jolly Ol' Saint Nicholas*, *Peaceful Easy Feeling* by The Eagles.

Of course, you don't have to rhyme at all (except for improv games where rhyming is the whole point). In fact, it's better to not rhyme at all than to deliver a crappy rhyme. "Not rhyming" works when you are telling an interesting story with your song, or moving the plot of your scene.

Musical Styles

In many cases, you can work the style of the song, as opposed to focusing so much on word associations or rhymes in your lyrics. Reggae, jazz, polka, whatever… each style has imagery often associated with it. Use that imagery in your lyrics.

Better yet, if you can weave the common imagery of your style into your associations and rhymes, the world will be your oyster.

See Appendix C for some quick tips on common music styles.

EXERCISE : "Radio Rhyming"

This is one for when you're driving in your car. During a song you know, let the band sing the first line, then sing your own, different line that rhymes with it. You'll be familiar with the tune, so finding a melody won't be a concern, and your familiarity will get you thinking up rhymes a little faster. When you get the hang of that, start doing it with songs you don't know. You'll get quicker at being able to come up with rhymes the more you practice. The final step is trying to come up with rhymes that are congruent with the lyrics being sung by the radio. When you're doing this with unfamiliar songs, you'll be amazed at how often you'll be singing the same word (the whole line won't be the same, but sometimes they'll be pretty close).

EXERCISE : "Boogie In Your Butt"

This is based on an Eddie Murphy song from the 80's. Start a slow, clapping rhythm, then have one person sing the first line. This consists of:
"Put a _____ in your butt" (and that person fills in the blank).
Trying to stay on the beat, the next person tries to rhyme with whatever the first thing is. Continue around the circle until someone can't think of a new rhyme. That person then just says "Put the Boogie in your Butt", and

everyone repeats it twice more before starting a new word (whoever couldn't think of the last one starts the new one). It's probably best to start with one-syllable things in your butt.

16

Scene Games

Basic scene work is your foundation for improv games. The scene is the skeleton, and the game is the skin. If the skeleton is weak, the skin collapses in on itself, and that's just gross.

There are literally hundreds of games that can be done in short form. By games, I mean some kind of special gimmick or format that is used during an improvised scene that ups the ante, or makes the scene more complex.

Here are some examples:

Blind Line - The audience provides lines of dialogue that are written on slips of paper. During a scene, the performers read a line (without knowing what it will say) and pretend like it's their next line of dialogue.

Comic Book - Performers read all of their dialogue from comic books, except for one performer, who tries to provide context for everything, and justify the lines.

Dubbing/Foreign Movie - A scene is presented where the performers move their mouths, but don't speak. Their voices are provided by other performers off stage. Or, the scene is presented in gibberish with off stage translations.

Forward-Reverse - Performers start a seemingly normal scene. At some point they must present everything they've done in reverse order, line by line until they are compelled to go forward again. This is done with the ringing of a chime, or someone simply yelling out "reverse" and "forward" at random intervals.

Moving Bodies - The performers doing the scene can't move their bodies; they can only talk. Someone else moves them around like marionettes.

New Choice/What/Should Have Said - Every time someone (usually outside of the scene) says New Choice (or whatever), the last line of dialogue spoken in the scene is taken back, and a new and different line must be given.

Sit, Stand, Kneel, Lie - During a scene, two performers can never be occupying the same physical position (from those listed in the name of this game). If two are standing, one must immediately sit, or kneel, etc. A good game to have four people performing.

As you can see, games provide an additional element to a scene. There are two dynamics involved with most improv games. On the one hand, it makes scene work more challenging. You now have something else to think about while trying to create a compelling scene.

The other thing is that most games have their own built-in comedy (see *Gimmicks*). Even a fairly pedestrian scene will get funnier when it goes in reverse (that's the theory anyway).

One thing that will make the built-in comedy more likely is if the scene itself is well executed. Some games are more challenging because you have less time to establish scene foundations before the "game" element kicks in. This is when clear, concise offers and endowments become even more important.

If you have to pay attention to what position someone is standing in, or what gestures they're making, or whether they are using proper nouns, or what order you mimed doing laundry, you're going to have a harder time picking up on subtle offers and nuances in the dialogue and action (especially the further into a scene you get).

Games are a great way to jazz up a short form show, and provide a variety of styles of improv. You can certainly do a short form show that simply has five to ten short scenes with no games or gimmicks at all. But, the novelty of a scene with extra characteristics appeals to most audiences, and it helps shake up the performers too.

Sometimes you can benefit from throwing in a game that has some built-in comedy. It can act like a burst of energy, or a rest stop in a show surrounded

by riskier scene work. It really depends on the make-up of your troupe, their skills, and what it is they want to be doing.

When you employ the improv games, especially the ones with unique mechanisms, you have to maintain a fine balance. Too much of a gimmick, and you're beating the audience to death with it. Too little, and they get disappointed. You've just described the game you're going to play, and how it has this unusual dynamic... you have to be sure to give it to them.

Example: There's a game called Pavlovian Response (or just Pavlov). In the game, each performer is triggered to do something unusual (bark like a dog, breakdance, slap yourself, sing a Bob Dylan song, etc.). They are triggered by something mundane that another performer does (touch an object, take three steps, make eye contact, etc). This is a game with an elaborate set up, but it has potential for being outrageously funny (or at least outrageous). However, if you have performers in the scene who aren't triggering each other, or not paying close enough attention to the triggers, the audience will hate this game.

You have to be sure you're providing the unique element for the game. But you also have to be creating an understandable scene (understandable to the audience, and to the performers). With a game like Pavlov, you have a lot to think about and do, and the more people in the scene, the more chaotic it's going to get.

Establish something fast, while there's time. If you know where you are, and who you are in the scene, you'll have more luxury to pay attention to the extraneous elements.

SET-UP SCENES

Some games use a short scene as a set-up. Then the scene is replayed in different ways (varying styles and genres, half the time, with more people, etc). The Set-up scene still needs to establish the same kinds of things you'd set up in a normal scene. You simply have even less time than you usually do to get it done.

There's also sometimes a need to work in every available player (or a set group or team of players) into the set-up. Since more people involved in a

71

scene can often mean more chaos, you really have to not only pace yourselves more carefully, listen more closely, and make clearer offers, you have to be aware of how other people are trying to "get into" the scene, and allow for those offers.

Set-up scenes are sometimes pretty sloppy. They usually rely on the rest of the game's structure (or gimmicks) to really make the game work. But, as you might suspect, a clean and funny set-up scene will make the rest of a game go more smoothly and heighten the results overall.

Set-up scenes are there to serve a purpose: Usually, tell a short story, utilizing as many players as necessary, and providing framework within which you will present an assortment of styles and/or effects.

The Tag

One of the most important elements of a set-up scene is giving the scene a nice button, tag, or punch at the end. Provided you have control over how the scenes end, or you have a capable person in charge of ending them, you can cue the ending by providing a clear tag.

The tag is a one-liner, summary, or big offer that brings the scene full circle, gives closure, or in some way lets things end on a high. It's often a good device for a person to use when they can't get into the set-up until the very end.

The tag is going to be even more important as you recycle the set-up for whatever game it is you're playing. Replays will give you a clear direction to take your scene as you replay it in a new style. You know you're heading for that tag line (which in the case of a stylistic replay can be modified to fit the scene's new style). A countdown scene uses the tag as the last beat of the scene.

Stage Picture

The other element that helps tie together a set-up scene is creating a visual stage picture. A big gesture, pose, or assemblage of your personnel will provide a visual cue for where a replayed scene needs to go, or when it should end. These cues are as much for the audience as they are for the

ensemble of performers. You're communicating to everyone "Here's the end of the scene", which will help if the scenes aren't generating as many laughs as you want. If that's the case, you are still making the scenes look clean, which is a nice discriminator against an unfunny scene that is also sloppy and unfocused.

For more on Scene Games, see Appendix A.

17

Styles & Genres

When you ask for styles, take them. Some styles you get all the time, and it's really no challenge to do them. Every once in a while, someone shouts out something clever or original. It may be extremely challenging, but you should always attempt it. You've already suggested you're game to do anything when you asked for styles in the first place. Walk the walk.

A very common element in improv games is the notion of doing a scene in a style. Whether it's a replay of a neutral set-up scene, or an entire segment of your show, style work is a tricky business.

You're basically going to get two kinds of genres as suggestions: the usual things, like Shakespeare and Film Noir, and things pretty much no one is familiar with (including the person who yells it out).

Shakespeare, Again

With the really common fare, you will quickly start seeing the same kinds of jokes and set-ups from your troupe. This is when your improv will start to turn into Mad-Libs. You're just going through the motions when you sling the same shtick every time. You have to break out of that.

The best way to avoid that is to really start taking a look at different genres. The temptation in studying genres is to bypass those genres you always get. "We know those already" is what you think. But do you really know them?

Start your genre dissection with the genres you think you know. The first step is to sit down with your whole troupe and make a list of every convention or detail you can think of for that genre. The second step is to actually take a look at that genre. Read a Shakespearean play (and not the ones you

already know). Make a second list of everything you learned from your immersion in that genre.

The first list will contain a lot of the "lowest common denominators" for that genre. It's the sort of things everybody thinks of when they hear that genre suggested. It's what most troupes will do when they present that particular genre.

Executing a genre necessitates the use of those lowest denominators, at least in part. What you are most likely doing is a parody of that genre (some groups sincerely do their best to execute an actual improvised Shakespearean play or a other style, but that's a pretty rare occasion). The reason you have to present those common bits is because in all likelihood, it's what the audience is most familiar with themselves.

Nevertheless, you don't want your entire presentation to be made up entirely of the same trite jokes, routines, and stereotypes. You have to sneak in little touches of the bona fide style.

The worst Shakespeare replay I ever witnessed sounded something like this:

> "I command you to walk-eth here-eth to me-eth, and take-eth
> this dagger-eth. Hey Nonny Nonny."

Frankly, this is the sort of thing I would expect an audience volunteer with no theatrical or improv experience to rattle off. I think the audience would prefer something along the lines of:

> "I beseech thee to come hither, swift as the Northern winds,
> and take from my wretched hands this implement of death.
> Hey Nonny Nonny."

The "eth" version is the result of putting no thought at all into what Shakespearean dialogue should sound like. It's not as if you have to be a literary scholar to be able to do it. You just need to take a look at the genre, and find the common trends and attributes. The audience is far more impressed with your ability to improvise authentic-sounding dialogue than they will be with your obvious inability to do it.

Attack of the Genre from Left Field

When you ask for a genre from the audience, you never know what they'll shout out. You can narrow the field by giving them categories like "literary style", "film genre", and so forth. Certain categories will elicit the usual responses, but every once in a while you'll get one that you've either never heard of, or never dreamed you'd get. Whoever yelled it out probably feels very clever, but now what?

If you don't know it, you can either reject the suggestion, or ask for an explanation or summary. I hate to reject any viable suggestion, and some people feel that a summary gives too much away. But you must evaluate whether anyone else in the audience knows that genre. Your parody may be lost on the audience, if they have no frame of reference.

With those rare styles you get that you've heard of, but aren't very familiar with or never performed, you have to dive in and revel in your ignorance. If one person in your troupe knows the style, follow that person's lead if you can. Otherwise, play up the fact that none of you know it, and you are barreling on regardless. The audience will identify with you, and often they will appreciate the attempt.

Here is a partial list of genres and styles that are most likely to be shouted out by an audience (not counting musical styles):

Absurdism	Drama
Action	Epic
After-school Special	Fairy Tale
Biography	Film Noir
Blaxploitation	Free Verse
Bollywood	Gangsters
Buddy Cop	Gossip Column
Burlesque	Gothic
Charles Dickens	Great Depression, The
Comic Book	H. P. Lovecraft
Commedia dell'Arte	Haiku
Disney	High School Play
Documentary	Horror
Dr. Seuss	Independent Movie

Infomercial	Radio Drama
Jane Austen	Reality TV
John Grisham	Role-playing
Kabuki	Romance
Kafka	Satire
Kung Fu	Schoolhouse Rock
Limerick	Sci-fi
Mamet	Shakespeare
Masterpiece Theatre	Silent Film
Melodrama	Sitcom
Michael Crichton	Slapstick
Mockumentary	Soap Opera
Musical	Spy
Mystery	Stephen King
News Broadcast	Surrealism
Noh	Suspense
Opera	Telethon
PBS	Tom Clancy
Poetry	Tragedy (also Greek)
Psychedelic	Vaudeville
Pulp Fiction	Western
Quentin Tarantino	X-Files

No doubt you'll be able to add plenty of styles to this list. If you can, try to make a few notes about popular conventions in each of the styles, or qualities that help set that style apart from the others. This will give you and your troupe something to work with whenever that style does come up (and ideally, your troupe will rehearse a lot of the styles). Whenever possible, it doesn't hurt to expose yourself to the actual styles… watch a couple of *Film Noir* movies, or a reality show, or see a play.

For more information on musical styles, see Appendix C.

EXERCISE : "Genre Zones"

Divide your stage into three or four zones (right to left) with tape or some other physical marker. Assign a different genre or style to each zone, and then perform an overall scene. Whenever you are standing in a zone, you

must take on its genre. If someone else is standing in a different zone, they are using a different genre. See how the mixing of genres affects your scene. See also which genres you seem to spend more time in than others.

EXERCISE : "Genre Re-Replay"

Do a short scene in no particular genre. Then replay the scene with a genre, but in the most stereotypical way you can imagine. Use every obvious convention and stock bit you can cram into it. Then replay it again, but don't use anything from the previous replay. See what new ways you can explore a particular genre.

18
Ending Scenes

Have patience, and the audience will as well. So many scenes are rushed. Sometimes silence and stillness are as good as a fast-talking monkey.

When you're doing a short form show, you have to know ahead of time how you plan to end your scenes (not just in matters of plot and time, but the manner in which they end). Basically you're either going to have someone *in* the scene end them, or someone not in the scene (another player backstage, an emcee not actually performing in the scenes, a person in the sound/light booth).

There's a variety of methods you can employ for the way you end scenes. ComedySportz has a referee (not in the scenes), who ends them by blowing a whistle and calling "time". Some Theatersports groups use a hand signal by anyone in the scene to end them.

Bells, lights out, music, a group bow, curtains… Find out what works best for your group, and practice doing it. It will be important for the audience to be able to tell as well. They're more likely to applaud in this case.

Some groups like to blend one scene into another, so the actual end of a scene is a bit fuzzy. It can be tricky, but looks pretty slick when done well.

However, if your show involves varying types of improv "games", or involves unique topics/suggestions for each scene, you are better served having a clear ending to your scenes.

Whoever ends your scenes (be they a part of the scenes, or off to the side of the stage, in the booth, what have you), you must agree upon what constitutes a good time to end a scene. Some groups use a fixed time (at

the end of four minutes, the scene ends, period). It's my opinion though, that if it's comedy improv you're doing, you have to end scenes on a laugh, if you can.

In this case, a combination of time and a laugh usually works well. As mentioned earlier, you don't have to resolve your story in most short form. Using a set time as a guideline, then looking for a sufficient comedic high will make a fine ending point for short form.

Having a good understanding of your group's typical scene "endurance" will help in setting a good time frame for your scene length. The endurance is the average time your group takes to create a coherent scene (establishing the important elements, supporting, and exploring) before a scene peters out and either loses its focus, or simply runs its course story-wise.

If your group's average scene endurance for short form scenes is, for example, eight minutes, you might consider setting your guideline time at about five to six minutes. This is when most of your scenes have reached their pinnacle, and are about to plateau in their entertainment value.

Naturally, these things will vary greatly from group to group and game to game, but you gotta start somewhere. After awhile, you develop a better sense of knowing if a scene is going to plateau early, or if a story really has legs, and the audience is craving more. It's always better to take an organic approach to deciding on when to end a scene (if you have the luxury to do so), but this can really only be determined by someone who either has a fabulous instinct for this, or is extremely familiar with the group's abilities and tendencies.

If you have the same person responsible for ending scene in all of your performances (or you rotate through the regular members of your ensemble) you're bound to increase your success.

Scenes under thirty seconds tend to be more like punch lines, but you nevertheless will probably still need to establish at least one element of a scene.

When your short form is not so focused on comedy, you need to redirect your energies to good, basic storytelling techniques. This is when a beginning,

82

middle, and end are desired, and when reached it is pretty easy to bring a scene to a close.

83

19

Confidence

Often improv is about "self-fulfilling prophecy". If you think you won't do well, you won't. Focus on your strengths, and trust your abilities. Also remember that most improv is team-oriented. There will be other people there to support you. Let them.

One of the greatest factors in improving my ability as an improvist was gaining confidence. I always knew I had the skills to do well in improv, but sometimes I didn't believe it. Part of me was holding back, and in retrospect, I see that it was largely self-doubt.

There was a spin-off group from ComedySportz DC called Emitts Boys. It was essentially five or six of the best guys on the DC team, who wanted to play together exclusively. I am sure part of it was the guys wanted to be able to do improv with people they knew were funny, and with none of the "funny-looking" players from ComedySportz. But part of it was that these guys rarely got to perform together on the same team. It wasn't all-guy on purpose (but I am sure it looked that way to a lot of people). Regardless, the guys in Emitts Boys didn't care what other people thought of them. They knew they were funny, and just wanted to put on a good show.

Emitts Boys was sort of co-founded by Brian Howard, one of the strongest improv performers I've ever met. He has tremendous abilities; commitment, characters, and can create a compelling plot out of anything. He also wouldn't hesitate to steamroll right over you if you were bringing a scene down. He knew it was technically not a very sportsmanlike trait, but his goal was to entertain the audience, who had paid for a comedy show. He'd hold your hand at practice, but not in a live performance.

Brian is such a focused player; he is darn near impossible to break up in a scene. It wouldn't matter how funny things were in a scene, he'd be there

with a straight face, going right along with it. I loved that trait. I also like it when performers get cracked up (or even crack themselves up), and I think the audience also enjoys it too. They connect with that. But a player who can keep going, unflappably continuing a scene is pretty rare.

At first, I was simply their sound and lights guy, which was still a tiny bit important, since Emitts Boys ended all of their scenes with a black out (you realize just how important it is, when you have someone doing it who has no sense of timing whatsoever). Good comic timing was necessary, and I'd been reffing ComedySportz shows for several months, and doing a good job with it.

After a few shows though, Brian pushed to have me as a player in the scenes. This boosted my confidence a little, but at the same time I was pretty intimidated. I wanted to prove myself, and I knew even the smallest screw-up would be magnified a great deal. For the first several shows I did, I really held back. I just tried to support the others, and let them take as much focus as possible. Even under those conditions, I managed to have some bad improv moments, and I was starting to sweat.

Then I had a break-through. In the middle of a game called "Mr. So and So", I managed to do something I'd never seen anyone else do. This was a game where the players would endow each other with bizarre character traits, like "Mr. Bad Scottish accent", or "Mr. Slaps himself when he talks". I'd been endowed as "Mr. Lack of tact", and somehow managed to become the central character in the scene. Toward the end of the scene (and it ran about eight or nine minutes), I was onstage with Brian. He asked me "Is it all right if we take your picture?" I quickly replied "Sure. Is it all right if I have an erection?"

This made Brian laugh. He actually broke in the middle of a scene. I don't think he was expecting my reply at all, and it was the most tactless thing I could think of (I should mention that Emitts Boys did a show for mostly mature audiences). When that happened, I was suddenly filled with more confidence than I'd felt in years. Ironically, that was one of the last Emitt's Boys shows we all did together.

However, from that moment on, I could sense my scene work improving a great deal. I was a lot more relaxed in all of my improv, and having a lot

more fun. It seems strange that a minor thing like making my friend Brian laugh in the middle of a scene would be such a boost, but I am certain that was what did it.

The only real way to build your confidence to is keep working on your improv. If you think there are areas where you have weaknesses, improve them. You can't ever stop learning, so keep taking classes whenever you can. You'll always get a new perspective when you train with different instructors and groups.

If your troupe can get someone to coach some of your rehearsals, you should go for it. Coaches will not only analyze scene work after you've done it, but they will often question your choices as you make them. This forces you to really think about what you're doing in a scene (which may be what is lacking). Sometimes it's hard for us to imagine we can be thinking about what's going on as we're improvising. You'll hear things like "Don't get inside your head", which means don't second-guess yourself, or spend too much time evaluating your choices. Nevertheless, your work will be better served when you can periodically assess your scenes, and really diagnose what a scene needs.

The only thing that's going to build confidence is a positive experience and success. When you're comfortable with performing, you'll start to have these experiences. If you aren't comfortable, then figure out what's holding you back. You have to tackle it head on, and when you do, your confidence will be bolstered.

20
Risk

Accept your support. Performers will try to build on things you have established, but any time there is ambiguity, there will be return offers that aren't what you had in mind. Try to accept them anyway, and work them.

I like the element of danger when I am doing improv. Some people don't. By danger, I don't mean using an open flame, or performing over a shark tank. I mean that energetic buzz you get when you have a lot of the unexpected going on.

After playing ComedySportz for several years, the element of danger was disappearing. One of the great things about the ComedySportz format is that it's a relatively safe show, and rarely bad. Two teams of players are alternating games, and all contributing to delivering a funny show. It's a pretty safe environment for competent improvisers.

Then I started doing DCUP shows. That feeling of danger- working without a net, was back with a vengeance! This was a different format than ComedySportz (not a lot, but enough), and it involved some games we'd never play in CSz. That made the show 100 times more exciting for me. Some of the DCUP shows were awesome. A couple sucked major mule. But it was still far more thrilling for me as a performer.

Being able to do a slightly riskier show made me really appreciate the structure that ComedySportz offered, and consequently made doing those shows more enjoyable.

Eventually, I decided we needed a little bit more structure in the DCUP shows, to increase the chances of a good show. It was just elements that would help harness each performer's strengths, and focus our energy. But

we all still wanted to have that feeling of danger, so we left much of the framework general.

One thing we always did was play Game-o-matic. We called it the Dare. We dared audiences to make us come up with a new improv game in every show. These games were often the best part of our shows. Many of the games were too goofy to ever play again, but some were pretty cool, and we *did* play them again. Some have even made their way into the ComedySportz game list nationally. The main thing about the Dares though, was that we were flying by the seats of our pants, and the audience knew it. They were right there with us, and it made the games work. We couldn't plan the gimmicks- we didn't even know if there were any. It was pure improv, and it was fabulous.

You can go too far with structure. Guidelines can turn into rules. Applying rules to all of your improv reduces your possibilities. A scene that could go places can be forced into a corner. Ultimately, troupes want to put on good shows. The key to this is developing and training the performers' skills and instincts, and then working within a show structure that takes advantage of those skills. By its very nature, however, you can't create a completely safe improv show.

Nevertheless, many directors try to do just that. It only takes one or two bad shows (and by bad I mean shows that had several bad moments, not necessarily the entire show) to make a director/manager decide that drastic actions must be taken. Never mind the umpteen many good shows that may have also taken place... the manager doesn't want to relive that crappy show experience ever again.

That is when standards and rules and cemented steps are brought in. Things like "During a scene, you always need a transition after a minute", or "Always make a guess after each clue in this guessing game", or "This person must say x, y, or z in this game". The elements of improvisation are narrowed, tweaked, refined, stifled, and shaped until players are essentially acting out Plug and Play games. Without the danger of failure, players won't commit 100%. Then their performance becomes about shtick, and bits. You do what you know will work. Some might call it honing your material, but I call it "being in a rut".

Improvisation is a team endeavor[14]. For the show to be its most successful, everyone involved needs to realize this. There are moments for individual accomplishment, but even those must be tempered by the needs of the show. If a player is going through the motions, working his or her time-tested shtick, then the other players have a diminished set of offers. They must either play along, setting the other player up with what they're asking for, or risk creating tension and discord by avoiding the obvious set up, and exploring new ground. Regardless, the trust of the team begins to deteriorate.

Managers are responsible for providing a good show. No one argues with that. But the show is improvised, and it can't be controlled to the degree necessary to *guarantee* success. The audience knows this. We have much more credit than we think we do. Most audiences are awed by the concept of improv (public speaking is still one of the greatest fears of Americans). They are delighted that we can get up there and perform (and be funny) on demand. They will be patient with us. They want us to succeed. They can sense when the players are really diving into uncharted territory, but if the players are having fun doing it, the audience will respond to this.

I know performers that can keep a straight face no matter how funny a situation is. The audience likes this. But they also really like it when something happens that is so funny even the players can't keep from smiling. Then the audience feels like they are in on the joke too. They connect even more. This kind of connection is what makes improv so great, and why live improv will always be better than taped improv.

[14] Except for those "one-man shows". But even then, the show has plenty of risk, even with a rigid structure. And, by most accounts, the people doing one-man shows have a pretty good grasp on what they're doing. We hope anyway.

21

Chemistry

When you find that saying "Yes, and" in your scene work is hard to do, you can be certain it's because of trust (and the lack thereof). Some part of you is reluctant to let the other person forge the path of your scene (because you know what's down that path... suckness).

They say the most important thing in a relationship is having trust. And they're right. It's also important for improv, especially for a troupe that performs together regularly.

When you trust the other performers, you can do anything. Your confidence is higher, your energy is stronger, and you simply have more fun. Sure, you can get a nice adrenaline rush from playing with people you don't know. But that's only good for one show. If after that first show you aren't starting to trust them, your adrenaline rush turns into constriction of the arteries. That will kill you.

Trust, of course, has to be developed over time. It takes a long time to build up trust, and only a few seconds to tear it down. One bad experience in a show can have you second-guessing the other performers, and making offers that leave nothing for them to contribute.

There are a number of "trust exercises" you can do with your troupe, but worrying about whether or not your partners will literally catch you when you Nestea® plunge into their arms is the least of your problems in improv[15].

[15] Oh, I suppose a concussion is more serious than denials. But chances are if you ever fell backwards in a scene after that, someone would definitely catch you (unless they all just hate you). The same might not be true of an offer you throw out which is never supported (and that will happen if they hate you regardless).

Chemistry is going to be more quickly developed when you and your partners seem to be on the same page with your scene work, and you truly respect each other's performance.

The rapport I have with the other members of DCUP stems partially from how much we enjoy performing with each other, but also from how much we enjoy each other outside of improv. Both of those sentiments owe a great deal to just how much we respect each other's abilities, and the fact that everyone in DCUP thinks everyone else is pretty darn funny. We find many of the same things funny, and that connection reinforces the bond we have on stage.

It may be impractical for you to chum around with everyone in your troupe. A lot of improvisers have "real jobs" they must perform, and actual families that want them around. This limits the amount of time they can bond with you. It might be worthwhile to spend a rehearsal doing some "team building". See a movie, or have a party.

I think it's funny that many improv troupes teach and perform team building seminars for companies and organizations, using improv. However, the troupes themselves may need to do something non-improv to heighten their chemistry as a group. They say you sometimes have to "stop and sharpen the saw". By that they mean your saw can be made more effective if you stop using it for a little bit and maintain it. They're pretty wise, whoever they are.

22

What to Wear

An improv performance is just that: a performance. What you are wearing will be looked at as costuming by some audiences. Just be sure you're wearing the right costume.

Once you are performing for an audience, you need to think about what the troupe is going to wear. With ComedySportz, the show is being performed as a sporting event, so the players wear athletic uniforms. This is all part of the presentation of the show.

Some troupes all dress alike. Others wear whatever they happened to already have on when they arrived at the theater. Sometimes the show has a theme, and the manner of dress is designed to reflect it.

Figure out what it is you're presenting to your audience, and dress to deliver it. If it's a casual, down-to-earth show, then perhaps jeans and a t-shirt will do. Think about how the audience is likely to be dressed. What do you think they are expecting you to look like?

In our regular DCUP show, we all wear black t-shirts with the DCUP logo on them. I like these shirts. I like the logo. I think it makes us look like an ensemble, and it helps brand our show. We want our show to immediately connect with the audience, and make ourselves accessible. If we dressed better than our audience, it might project a barrier between us (it could project status that we don't want projected).

Other groups dress very well for their shows; suits, ties, dresses. This is the image they want to project, and it generally meshes with the show they want to present. I for one don't like performing in a suit and tie. I can do it, and I have done it plenty. But given my druthers, I will wear something very comfortable.

Every troupe must decide what is going to work best for their show. Should they wear the exact same thing? Dress in different outfits with the same style? Uniform color? Dress as chickens? Complete hodge-podge? Whatever you decide will become part of your image (whether you were thinking about your image or not).

I believe in many cases what you wear in your show will take a backseat in the audience's mind compared to how well you perform. I've seen amazing improv from people dressed like college dropouts. And I've seen sharply dressed people do crappy improv. I left those shows thinking a lot more about the quality of improv than what the people were wearing.

Nevertheless, it can have a subtle influence on the audience, as well as your own outlook. If you feel like you look ridiculous, it can taint your performance. If you are uncomfortable in your clothing, you may not perform as well as you are able.

Get with your fellow performers and come up with some ideas about what you should wear to the shows. List the pros and cons, compare and contrast with other troupes you know (perhaps you want to visually set yourself apart from the others), factor in your budget, and come to some consensus.

And you can always ask the audience what they think.

23

The Wall

Don't punish yourself for getting tickled by what someone else has said or done (or even something you did). Smile, laugh, cry… but get back to the scene as soon as you're ready.

Every once in awhile (or worse, all the time), you run into a wall in your scene. You reach a point where you just don't know where to go next. You and your partner(s) have seemingly run out of ideas in the midst of your scene. Suddenly you feel pretty naked up there, and you can sense the eyes of the audience on you, waiting for… something.

Here's where having a plot would have come in handy. It's all well and good to just coast through scenes sometimes, working your character, seeing where things head. But some part of your brain should periodically raise the periscope and see if you're telling any kind of a story.

Still, no matter how good a storyteller you are, you're likely to run into a wall sometimes, so what to do? Well, here's what *not* to do: Don't give up. Don't bail on your scene, no matter how tempting.

You see, the performers have an advantage over the audience at this point. They don't yet know that you don't have a clue about where to go next in your scene. They're a step or two behind you for most of the performance. How are they expected to know where your scene's going to go when sometimes you don't have the faintest idea? When that realization hits you, you've still got a few moments to do something before the audience suspects you are floundering.

One thing you can do to try to reboot is a quick "scene diagnostic". Ask yourself if there's anything that hasn't been clearly established (the usual

suspects: character, relationship, setting, and the old black sheep of the family, plot).

If you're satisfied that you and your partners have a clear context for your scene, check the Table of Offers, and see if there's anything that was brought up earlier in your scene that wasn't fully explored. This may involve backtracking a little, but remember improv doesn't have to be linear.

If all else fails, create conflict. Conflict is the old story standby. It doesn't mean you should necessarily start a fistfight (literal conflict isn't generally called for, though it does make a nice spectacle). You just need to figure out what someone's character (yours or anyone else in the scene) needs or wants, and create an obstacle. The most common obstacle is another character (and that character's agenda).

I saw an entertaining show with WIT (Washington Improv Theater) about a guy who wanted to throw a holiday party. Before long, the party was in progress. Guests were there, things were fine, and it suddenly seemed like they were heading for the wall. The guy playing the main character managed to explain *why* he wanted to throw the party. It was because he really wanted everyone to get to know him. In moments the other performers were creating reasons for his character to not be able to achieve this. The reasons got more elaborate, and consequently more amusing.

Identifying the objective of a character, and putting up hurdles made that scene take off. Some people might worry that hindering an objective is a form of denial. I don't believe so. I also don't believe in achieving objectives in short form. Work toward it. Make it look like every effort is being made to get there, but don't reach it. The others can also *look* like they are helping, but in reality they should be fighting you all the way.

Where do you go when you've accomplished the thing your character wants most? One place: a wall.

> "Oh my God, the couch is on fire!"

> "It's all right, here's an extinguisher."

Well, that's nice. Now you're back at square one. I think instead of solving a problem you should make it worse. I'm a big fan of cascading problems (as you try to take care of one thing, something else happens to exacerbate the problem). You can grab that fire extinguisher, but maybe it's expired. Or perhaps someone filled it with gasoline as a practical joke. Improv is about forks in the road. Putting the fire out is a dead end.

Sometimes you aren't in a scene, and you can tell the others have hit the wall. The pressure to jump in there and "save the scene" is strong. As a performer, you know those guys are like astronauts outside of the spaceship without their helmets. In seconds, they run out of oxygen and die. A voice in your head is screaming, "Do something! Anything!"

Well, there's probably a lot you can do, but *anything* isn't one of them. I don't feel you should jump into a stagnant scene without a clear idea of your offer. If you take a moment and think about what specifically the scene needs, you have a much better chance of actually helping. If it were simply a matter of doing "anything", the folks in the scene could do that[16].

And yelling out, "Meanwhile, somewhere else" is only a step above bailing on the scene. If that's all you got, it's all you got. But it's addressing the symptoms and not the cause. If your scenes are winding down before their time, you need to find out why. It's probably a lack of plot.

[16] Sure, you'll have times where the people in the scene don't know what they're doing from the get-go, but if your presence is actually going to help with *anything* you do, why the heck did you leave them in the first place? If you're performing with capable people who have hit the wall, get your ducks in a row before you jump in there.

24

Rehearsals

*Practice makes perfect if you have perfection within you. At
the very least, it staves off "suckness".*

A lot of times "normal" people (by which I mean non-improv people) will ask
me why we bother to rehearse if everything is made up. These are usually
the same people who are too chicken to even try it themselves, so the
thought that improv is a skill that needs to be developed and maintained
doesn't occur to them. Who needs normal people anyway?[17]

Some people have tremendous natural abilities when it comes to improv.
But improv relies on such a wide range of individual skills, everyone doing it
can benefit from practicing. You never know what will come up in a scene or
game, so you never know what sorts of skills could come in handy at any
given time.

We also tend to get a lot of input from the audience, from scenarios to
genres. We typically present ourselves as prepared for whatever they (the
audience) wants to challenge us with. In order to step up to that challenge,
we need familiarity with almost anything the audience can shout out or write
down (and that's a pretty tall order).

Rehearsal is a must for any troupe. There are three basic things you can get
from practicing with your fellow performers.

First you educate yourselves about each other, not only with regard to
experience levels and the basics, but with what specialties each performer
has. If one person in your troupe is especially good at certain things (musical
games, physical comedy, etc), you can learn from them.

[17] We do. We need them in the audience, watching our shows (because performing for other
improvisers gets tiresome quickly, and they never pay to get in).

The second thing is developing those skills you haven't mastered. If Shakespearean-sounding dialogue doesn't roll off your tongue, you really need to practice doing it. Watching the Kenneth Branagh collection will only get you so far. Most people learn best by *doing*. Fellow DCUPer, Claire Lambert used to dread musical games. We devoted an entire rehearsal to working on the 7-5 technique and word associations. Now, while still not her most comfortable part of improv, musical stuff is enjoyable, and frankly she kicks some butt when she does it.

Finally, you start to develop chemistry with the other members of your troupe. This is arguably one of the most important facets (it has its own chapter, after all).

Rehearsals are the time for taking the biggest risks, and seeing what comes from it. An audience isn't paying to watch you fail, so you might as well go out on the longer limbs in the safety of a rehearsal.

What you need to do, to make the most of your rehearsal time, is have an agenda. Identify the areas where your troupe needs the most work, and start addressing them. If basic scene work is not coming together, then surprise, you need to work on the basics. This doesn't mean you all aren't capable of doing good scenes, or that you don't actually know the basics. But chances are you all learned them in different ways, with focus on different skills or philosophies. You need to all be on the same page in at least a couple of ways, or else you end up fighting each other on stage.

 The fully democratic approach to running rehearsals has its ups and downs. Sure, you might step on fewer toes, or egos will be soothed, but you might end up accomplishing less, and making more trouble for yourself in the long run. I think it's better to have a single person conducting a rehearsal. It doesn't have to be the same person every time (although having a Director can often create a consistent approach).

In either case, let everyone know ahead of time what you will be going over, and why. Don't waste a lot of time arguing about what choices worked or didn't. That situation might never present itself again in a scene. We can't predict how well a choice will work, or how soon a transition will be needed, or what kind of characters will operate well together.

All we can do is hone our skills, develop our trust, and do our best to become as talented a troupe as possible. Creating "rules" for everything your troupe does is not the answer. A good troupe doesn't need rules, and a bad troupe isn't helped by them.

If possible, you should have rehearsals on a regular basis. Get a consensus about how often is realistic, and stick to it. If you can't get a majority of your troupe to a rehearsal, you have to address it. Ultimately your shows may suffer if you aren't getting in some practice.

Suggested Rehearsal Schedules

At the very least:
1. Entire troupe (at least 75%) gets together once a month for two hours. Rehearsal is conducted by a senior member of the troupe (or a rotation), with an outline for the full session. Start with whatever warm-up you all consider to be the most fun[18]. Use the first hour for generalized work (short scenes, new games), and the second hour for more specific and focused topics (genre work, problem areas).

Large troupes:
2. Bi-weekly practice for the whole troupe (at least 50%). One person runs the whole practice, or divide it in half with two each running one portion. Warm-up the group with something quick and fun. Do some notes at the halfway point of the practice (addressing things you've just done, or issues from previous shows). Spend the second half of the practice doing fun stuff (bizarre games, experimental crap, etc).

Best-case scenario:
3. The troupe has a practice every week. Topics are scheduled, and practices are directed (by a member of the troupe, and guest directors whenever possible). Outside influence will give you new perspectives on what your performers are doing, and things to consider. After practice, you all go out for a bite to eat and make fun of the troupes in your city that don't rehearse.

[18] Warm-ups at practice are sometimes ignored, but I feel it helps jump-start the group. Not that it necessarily gives them energy, but it does tend to confine the lackadaisical first ten minutes of a practice to the warm-up portion, rather than affecting the actual rehearsal time.

103

25

Auditions

*All the preparation in the world will mean bupkis if you are a
bundle of nerves. Meditate. That crap works.*

I've only auditioned a couple of times in all my years of doing improv. Most
of the time, I already knew someone in a group I wanted to join, and they just
added me to the line-up. The rest of the time it was *my* group, so I still knew
someone on the inside.

I've held auditions before, so I know what I was looking for at the time. Two
things: Attitude and funny.

Since I've always been involved in comedy improv, I'm always on the lookout
for funny people I think I can teach improv to, and get them performing. I've
seen people audition before who clearly had theatrical training, and could do
improv, but just didn't bring the funny in their audition. I've said it before, and
will say it again: you can't teach someone how to be funny.

If you are auditioning for an improv group (that does comedy improv), you
gotta show your sense of humor at the audition. If they don't see it, they
won't assume you have it.

Attitude is a little more vague. With ComedySportz, we wanted to make sure
we had people that we thought would get along well with the people already
doing it. We'd had people in the troupe before who, while funny, were a
burden to be around because of their attitude. They complained a lot, they
couldn't leave their baggage at the door, they gave notes in mid-show.
ComedySportz is team-improv, and trust is very important. If you don't trust
someone on the team (and worse, no one on the team trusts them), it will
affect every aspect of the performance.

It's also kind of hard to judge someone's attitude from an audition, so
everything gets magnified. It if looked a little like you were railroading, or

annoyed with someone's offer (or denial), it got translated as a huge attitude element.

You need to determine what you want before you audition people. Naturally, everyone wants really talented improvisers who are very funny, and no major hang-ups or addictions. What's your second choice? That is, if you get a mix of talented people who are an emotional wreck, and stable, yet unfunny folks with theater degrees, who do you want? Maybe a mix is best (good luck with that).

NERVOUSNESS

Everyone is nervous at an audition. The trick is to appear like you are *not* nervous. My friend Spencer Humm has a good formula for not appearing so nervous while performing.

1. Breathe
2. Relax
3. Breathe
4. Relax
5. Breathe

As you can see, there isn't a whole lot to remember, and more than half of it is a natural act our bodies perform anyway. Sufficient oxygen will help you to relax[19], and relaxing will not only help you appear less nervous, it will allow your brain to operate more efficiently, and as a result you're more likely to do your best.

Having fun helps too. Most of us do improv because it's fun[20]. If you can have fun at an audition, you'll probably have a pretty good audition. You'll also seem more like the kind of person other people want to perform with. You may never know what someone is looking for at an audition, but a "curmudgeon" is probably not high on the list.

[19] Too much will make you pass out.

[20] We aren't in it for the money, most likely. In fact, sometimes it doesn't pay at all, but we still can't resist doing it. Getting paid to do improv is great, and while it shouldn't be your goal to get paid to do it, it should be a goal to do improv that's so good it's worth whatever it costs to see it.

106

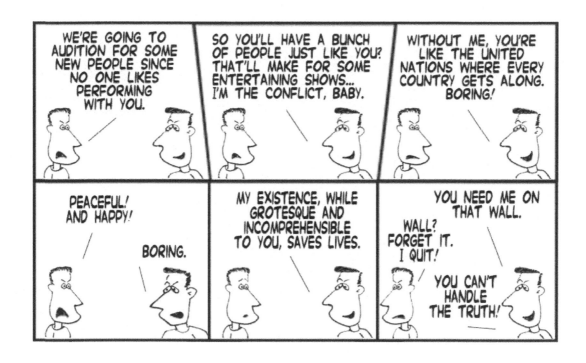

26

The Audience

Give them at least their money's worth. Sometimes they aren't paying at all- but they should still be entertained.

I can't speak for all improv troupes, but I know I am up on that stage to perform for and entertain an audience (preferably a paying one).

Reading the audience is a skill by itself, one that can take years to master. Then of course, once you *can* read an audience, you must decide what to do about their reaction, if anything.

Should we cater to the whims and desires of the audience as we perceive them, even those that are the most base?

Well, have they paid to see you perform? If so, it's possible you owe them something. You can take the position of "This is an experimental art form, and you get what you get", but if that's how you justify an unresponsive crowd what you *won't* get is much repeat business.

Does this mean your improv should be the lowest common denominator? That's up to you. Are you trying to appeal to the widest margin of audience possible, or to an elite segment of the improv-going community? Do you even care? Get a consensus of everyone in the troupe, and see what they want an audience to walk away from your shows with.

The first phase of reading an audience is determining whether or not they are enjoying what you're doing. If so, you can either give them more of the same, or use their good will to venture into riskier, uncharted territory (or "raise the level of art"). What happens with the good will at that point will depend on whatever the heck it is you're going to do, and the make-up of the aforementioned audience.

One of the benefits of short form is the notion of clean slates. Scenes are often short and plentiful. If a scene goes well, it helps launch the next one. When one bombs, it can hopefully be forgotten in the wake of a stronger, funnier scene.

If an audience doesn't seem to be reacting well to anything you're doing, two possibilities exist. One, the audience, for whatever reason, had one set of expectations going in, and your show is not what they thought they were going to see. The other possibility, not to put too fine a point on it, is that your troupe sucks.

Hopefully the latter is not the case (at least not your *whole* troupe). Provided it isn't, you need to examine what you think the audience's expectations for your show were, what they should have been, and how to correct it.

Providing an introduction to your show can help out immensely.

At some DCUP shows, we explain what improv is right at the beginning of the show. We find out who is new. We practice soliciting topics and suggestions. We warn them about the possibility of adult material in our show[21]. Then we warm up the crowd by singing a short, improvised song together.

I feel like it puts most of the audience in the right frame of mind. I also test the waters insofar as how loose they're feeling, how involved they get in the warm up, and the caliber of their initial suggestions.

Many of the techniques and elements of the DCUP intro were culled from the ComedySportz intro, which is time-tested and generally considered an invaluable kick-off for that show.

We also outline pertinent information in our programs for the show. It explains here, as well, what improv is, how the show is interactive, and any other info that is specific to that night's particular show. The program also gives the audience something to look at and consider while waiting for the show to start.

[21] This is the point that Steve Heaton will yell profane things out from behind the curtain.

After you've done all you can to prepare an audience for your show, you're still gauging them throughout your performance. This is done through numerous processes. When you've done things to make them laugh, you start to get an idea about what sorts of things they seem to find amusing.

You also may get an inkling about where "the line" is in regard to what material they will object to (regardless of whether your show is clean or not). Once they groan or gasp, you know you've crossed that line.

When the line has been crossed, most performers take that as their cue to pull things back into safer territory. A few of the bold and brazen will barrel on, heedless of the disdain or outright horror of the audience. While it is possible, on rare occasions, to so thoroughly lambaste an audience that you win them over with your brilliantly crass delivery, I would suggest erring on the side of caution. They might not wait around long enough for the tide to turn. Setting up such an expectation in your introduction will probably help.

Certain other factors are worth observing. Is the audience responding to physical humor? Do they enjoy references (and how obscure)? How high brow can and should you go? Is political correctness a consideration? With many audiences you just won't know until things start cropping up in your scenes. While it probably isn't preferable to continue slinging the same general brand of material throughout your show (keep those dick jokes coming!), it can sometimes help to know what areas you should give a rest.

INTERACTION

I feel that one of improv's greatest attributes is its interactive nature. The audience isn't just watching the show; they are a part of it. Probably it's a very small part of it, but sometimes they can get really involved. This connection is not only a fun part of improv, it can also make your show that much more successful. Being part of the show, the audience now has a stake in how the show goes. That can be an important asset when you want to push the envelope or take much bigger risks.

Suggestions

The most basic and common form of interaction is suggestions. These are the topics and themes we get from an audience. Our improv is based on these suggestions, or inspired by them. And, they are a way for us to "prove" what we're doing is really "made up on the spot".

There are a variety of ways to solicit suggestions, and you aren't confined to the same method throughout a show.

1. Fill in the blank. Start a sentence, and have anyone finish it. "I would never want to go to _____".
2. Day in the Life. Find a volunteer (or create one), and ask him or her details about their life. It can be general information about them, specifics of a typical day, a special event. Find out who the key players are in their life, and get a word or two to describe everyone.
3. Slips and Forms. Before the show, circulate slips of paper, or forms for people to fill out. They can provide any kind of suggestion (occupations, locations, objects), personal information (names, jobs, phobias), lines of dialogue, etc. You can ask for specific things, or leave it wide open. These can be collected and used at the start of the show, or periodically during it.
4. Just shout it out. Ask the whole audience, or any portion thereof to shout something out. Again, you can ask for specific things, or just say "anything". You can also ask for actual scenarios: "What problem are they experiencing?" "Who will visit them?" "What will happen to John?"

It helps to know what sorts of things you want before you go getting them. That way, you never look like YOU are struggling for a suggestion. You should also decide on the way(s) you want to get suggestions for a show before it begins.

Getting the suggestions is part of the show, and you should have as much fun with it as you can. Sometimes the audience provides stuff that is funny all by itself (and they can have fun giving suggestions). If you have somebody in the audience who is having just a little too much fun giving input, get control of them early. Never let the audience run your show.

You should also try to use the things they give you. Many a time a scene has unfolded that ultimately had nothing to do with the suggestions. Most

likely the audience won't remember; if the scene is good. But whoever yelled out the suggestion will be disappointed.

You don't have to make the suggestion the very first thing that comes out of your mouth in the scene, and it doesn't have to be obvious how you plan to use the suggestion. One thing I caution however, is trying to be overly clever with your "interpretation" of a suggestion. If someone yells out "Iraq" as a suggestion, and your scene goes like this:

> "Hey, what are you building?"
> "A rack."

Then I don't blame the audience for throwing shoes at you.

Volunteers

Involving a member of the audience in your improv can be wonderfully exciting, challenging, funny, and liberating. It can also be a disaster.

Many improv games are extremely well-suited to having a volunteer.

1. *Columns.* One or more volunteers are seated on either side of the stage. When you need input, you tap them on the shoulder, and they complete your sentence or fill in a blank.
2. *Dr. Know It All.* Stick a volunteer somewhere in your line of players. They probably won't answer as quickly as the rest of the group, which just makes you look better. They are also more likely to mess up, but the rest of the audience never cares.
3. *Moving Bodies.* Make the volunteer the mover (or one of them). This often makes for several justification moments (why you aren't moving the way your dialogue would indicate you should).
4. *Foreign Movie.* The volunteer is made to speak in gibberish, and you provide their translations. Dubbing works well here too.
5. *Bedtime Story.* Tell the bedtime story to the volunteer, and set him or her up for input. "He reached into his pocket for money, but all he had was a... what?"

Even a normal scene, free from games or gimmicks can involve a volunteer. You really have to walk them through the scene, and do a lot of endowing,

but the contrast between the volunteer and the actual performers will be stark, and it usually means the performers look all the more sharp. Plus, the input from the volunteer will really keep the others on their toes, and it makes you so much more aware of how important good offers and listening really are.

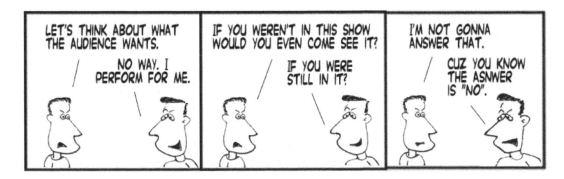

Appendix A

Tips For Common Short Form Games

185 (186/Two Blanks Go in a Bar)
[A "jump out" game, where all the performers stand in a line, taking turns delivering a terrible joke in a the following format: "185 ___s go into a bar. The bartender says we don't serve your kind. The ___s respond with (punch-line)." The blanks are provided by the audience, and the punch-line is a punny word association. Example: "185 bananas go into a bar. The bartender says we don't server your kind. So the bananas say, "This place already didn't have appeal (a peel, get it?)."]
-Try to avoid using stock material unless you and everyone else have nothing.
-Sell the bad ones… act like they are really awesome.
-Set it up properly if the punch-line is a stretch (albino New York bananas instead of just bananas).

6 O'clock News (Headline News)
[This is a news broadcast about something mundane, or an event in some audience member's life.]
-The News Anchor should set up all of the segments, and recap periodically.
-Other segments should be longer than a one-liner.
-Use every bit of a typical newscast (sports, weather, traffic), but relate to the Suggestion.

Advice Panel (Good Advice, Bad Advice, Worst Advice)
[Performers portray characters who dispense advice to the audience. Typically the first person gives generally good advice. The second gives pretty bad advice. The third one gives horrible advice, or non sequiturs.]
-Good Advice should be good, but overly good, syrupy, sappy, extreme.
-Bad Advice should simply be bad advice… the opposite of what you'd expect as normal good advice (not necessarily the opposite of the Good Advice person) but justified.
-Worst Advice should be more over-the-top than the Bad. Feel free to get weird.

Alphabet
[This is a scene where each successive line spoken by alternating performers must begin with the next letter in the alphabet.]
-Keep the pace brisk.
-Try to say real sentences, and not resort to Yoda speak.
-Don't repeat a word that was used to start a sentence.
-Keep doing some activity.

Arms Expert
[One person speaks, but another one provides the arms.]
-Arms player should listen to the Talker, and vice versa.
-Get the Talker to demonstrate things.

-Talker should justify what the Arms are doing.

At the Movies
[A Siskel and Ebert[22] type of scene, about movies. Usually features "clips" from those movies.]
-Set up the players, but don't give everything away in the setup.
-You can make the game about one movie, or several.
-You can have one reviewer or two, if you have enough players.
-Make the Movie Clips be the best parts of those movies.

Audition
[Performers portray people auditioning for a play. Another performer is the director, and instructs them about the characters and scenes.]
-Let the Auditioners introduce themselves, and give their experience.
-The Director should set up the scene with background info for the "actors".
-Feel free to use many conventions of a theatre production.
-Actors should be contrasting characters.

Award Night
[A satire of the Oscars, but for something other than movies… like plumbers, or hostages.]
-The Host must keep things moving, and doesn't have to talk a lot each time.
-Use as many Oscar/Emmy elements as you can think of (lifetime award, clips from films, dance numbers, teleprompter, backstage, sponsorships, bad speeches).

Back to the Future
[A naïve scene, where a guesser must figure out what occupation/household item/historical event has never existed or occurred in the course of a scene that depicts what the world is like without them.]
-The Guesser doesn't have to give a real guess during the scene; just insinuate you know.
-Each player should be the focus of one of the elements, assisting others when needed.
-Keep the scene itself moving. Let the suggestions be part of what moves the scene.

Ballet
[An improvised ballet, which is usually broken up into segments that are introduced and/or outlined by a commentator of some sort.]
-The dancers can freeze periodically so the Host can explain what happened/what's next…
-Try to tell a story through the dance. Use many dance styles and conventions.
-Dancers should avoid talking, singing, etc. But there are no real "rules" for this game.

Beastie Rap
[A two team rap game where the font person from each team sets up the rest of the team with a name or word they must say in unison. The other team will be set up with a word that rhymes.]
-Don't start every round with "I know this guy and his name is…" Be creative.
-A good way to set up is using opposites ("He's not low, yeah you know he's --)

[22] Both of those guys have passed away, so the name may be totally meaningless to you. So sad.

-Call yourself out creatively: give funny non-rhymes, dance break, etc.

Bedtime Story
[A performer pretends to read the favorite book of an audience member to them. At periodic intervals, the performer prompts the audience person to state what happens next. Other performers act out the story while it's told.]
-Set up the Audience Member with things that don't have obvious answers.
-The Reader should let the other players move the story along as well.
-Help the Reader set up opportunities for the Audience Member to give input.

Blind Date
[Performers act out a date between two audience members who don't know each other.]
-Exaggerate the info you get about the people. Make them caricatures of themselves.
-Be sure to actually get to the date.
-Let the characteristics of the character be what makes the date work (or NOT).

Blind Line
[Players perform a scene, and periodically read a line of dialogue written by the audience. The line is then justified in the context of the scene.]
-Take turns reading lines.
-Don't pre-justify every line you have (you can simply read a slip).
-Do justify why you've said what is on the slip.

Blitzkrieg
[Players act out stories involving a naïve guesser as one of the characters. The guesser must figure out what movie, book, TV show, musical, etc. he or she is in, and only gets one guess. Often played with two teams acting out with two guessers.]
-Involve the guesser... make them one of the characters.
-The MC can cue the medium ("What Movie are you in?", "What classic play are you in?")
-Use sounds effects and music as part of your gibberish.

Chain Murder
[A naïve player is given clues in gibberish about the location, occupation, and weapon used in a murder. When they think they know them all, they "kill" the clue giver. The killer then gives clues to a second naïve player, and the process repeats. Killer two gives clues to a third killer, who then guesses at the end of the scene.]
-Try to make the guesser the Occupation (if you can).
-Don't do the same mime and clues as the person before you.
-Kill the victim creatively, rather than just beating them with the object.

Changing Styles
[Players do a scene, and an MC shouts out varying styles the scene must then take on (music, literary, movie, emotions, etc.).]
-Keep eye contact, so everyone doesn't talk at once after each style change.
-Keep the scene moving, using the styles as ways to progress the action.
-Use the biggest pimps for each style (you only get the style for a few seconds)

Comic Book

[A performer does a scene where everyone else provides all of their dialogue from comic books they carry. Every comic book line is justified by the player not reading from one.]
-Don't get all the comics into the scene too fast.
-Let the Straight guy justify every line from a comic (don't pile up lines).
-You can exit a scene if you have a comic (and transition to other scenes).
-Comic readers can also read ads, letters, sound effects, and exposition.

Countdown (Half-Time)

[Players do a scene that is about 1-2 minutes long. They then replay the scene in half the time. Then again, and again.]
-The setup scene should consist of at least *some* action.
-The first replay should have the same(ish) lines, delivered more quickly.
-Subsequent replays should get more and more paraphrased.
-Last replay should be one overall word spoken by each player (just a guideline) .

Criminal Mind (Crime Story)

[A naïve player must confess to a crime (including certain details like murder weapon, location, etc.). The interrogators give clues while trying to get the confession.]
-Guessers should make guesses (or offers that suggest a guess) throughout the game.
-Clues should start very vague and esoteric, then get more obvious.
-Teammates CAN assist a clue giver if they are having trouble with the guesser.
-Guesser should act like they know who they killed, etc., but act evasive, ironic, sarcastic.

Crystal Ball

[A naïve player must guess the fortune of another player. Remaining players give physical clues as they act out the fortune, as if inside the crystal ball.]
-The Customer should only steer things, not give too many clues.
-The Fortune Teller should indicate the Crystal Ball is cloudy, and use that to justify guessing.
-Players "in" the Crystal Ball shouldn't talk or make sounds.

DVD

[Performers do a scene as if it's part of a DVD. An MC can interject with DVD features the players must present.]
-Make the movie about something. Use big characters.
-"English" Subtitles means the actors speak gibberish, and get translated.
-Clear the stage when there is a chapter change.

Da Doo Ron Ron

[Players sing the old song "Da Doo Ron Ron", using names from the audience, and rhyming that name with every line of the song. Every third player must do three rhymes in a row (sing the song, and you'll understand).]
-Emphasize the last syllable in multi-syllabic names (example: "his name's Ste-VEN")
-Avoid using the phrase "his favorite *whatever*..." It is overdone.

Day in the Life

[An event or typical day in the life of an audience member is turned into a scene.]
-Exaggerate the traits of the Audience Member. Make them into a caricature of themselves.
-Use the information that you get. Keep your story along a parallel of their day.
-Don't rush through the day. No need to get to the end.

Dime Store Novel

[A player narrates a story that is being written. The other players act it out.]
-The Writer should set up the others, and let them set up themselves.
-The story does not *have* to be Film Noir in its style.
-The Writer can rewrite a scene, or lines, making the players do new things.
-The Writer can use flashbacks, dream sequences, and anything else.

Dr. Know It All (Expert)

[Players are standing in a line, answering questions from the audience, but can only say one word at a time.]
-Speak quickly, but try to make an actual sentence
-Always refer to yourself as "me" or "I", and not "us" or "we".
-Only use the one-word answer gimmick once
-Start most of your sentences by rephrasing the question

Dubbing

[Performers in a scene move their mouths but do not speak. Their dialogue is provided by other players.]
-As a Dubber, watch your Dubbee, but also be aware of the other Dubbees.
-Take turns moving your mouth as a Dubbee.
-Keep doing some action as a character on stage.
-Move the story along as a Dubber.

Elimination Rap

[Performers stand in a line and rap on a topic. Each player must set up the next player in the line with a rhyme. After the next player rhymes, he or she raps another line that sets up the next player. People are eliminated for not rhyming.]
-Set up the other players… no need to stump them with Orange, Month, Butch, etc.
-If a team is getting whittled down, a player from the other team should take a dive.
-Be a rapper, milking the genre for all its worth.

Eliminator

[During a scene, the MC stops the action and asks the audience to vote someone out of the scene. Their character remains, and must be played by the remaining players.]
-Use big contrasting characters, and have a hat or other costume/prop.
-Make the scene be about something… action is not a bad idea.
-The person picking eliminations should keep the audience favorite, or the person who will really be able to sell all of the different characters.

Emotional Party

[Each performer is given an emotion. As they enter the scene, everyone in the scene takes on their emotion. When a player leaves, the scene reverts to the last emotion everyone was expressing.]

-Try to separate similar emotional energies.

-Use a differing style of a particular emotion when you are sharing it with someone.

-Keep the party going, trying to find a plot to the scene.

-Justify your exits.

Emotional Symphony

[Players stand in a line, performing a conducted symphony. Instead of musical instruments, each player channels an emotion.]

-Vary your emotion, but do so according to how you are conducted.

-It is okay to occasionally work in a word or phrase that is apropos, but sparingly.

-Remember, this is music, so try to sound like an instrument or section.

-Don't repeat the same rhythm that someone else is using.

-Watch the Conductor very carefully so you adjust quickly.

5 Things

[A naïve player must guess what activities he/she is performing. Clues are given in gibberish. The activities are usually embellished, with portions replaced by bizarre audience input.]

-Don't do the activity as the clue giver; make the guesser do it.

-Make sure you indicate which element is being replaced, and throw it away.

-Fill the void with sound effects and gibberish.

-As the guesser, always do the activity, modifying the action as elements change.

-Pay attention to who is doing what, and keep the action moving.

-When time is running out, go FASTER!!!

Foreign Expert

[One player is an expert from a made-up country, and doesn't speak English (or whatever language you normally perform in). The expert has a translator, who not only translates the expert, but also the audience's questions (into the expert's "language").]

-Have fun with your gibberish, and use gestures as well.

-The Expert should alternate giving obvious answers and clearly unrelated ones.

-In turn, the Translator can base the translation on what the expert "does", or something completely different.

Foreign Movie

[Players do a scene in gibberish. Their dialogue is translated by players not in the scene.]

-Let the person get translated before speaking another line of gibberish.

-Only use the long translation for a short line of gibberish gimmick once.

-Only use the short translation for a long line of gibberish gimmick once.

-Gibberish actors should be "doing" something in their scene, not just talking.

Forward/Reverse

[Performers start a scene. At any point the MC can yell "Reverse". At that point, all of the dialogue and action must proceed in reverse order until the MC yells "Forward".]

-Do the scene in short beats. They're easier to remember backwards.

-Let the scene be about action, rather than talking heads.

-Let the other people remember their Reverse lines in order before delivering yours.

Freeze Tag

[Players do a scene until someone else yells "Freeze." The players in the scene freeze, and are tagged out and replaced by whoever yelled freeze. A new scene starts based on the positions.]

-"Freeze" should be yelled at a regular pace, even if you don't have anything in mind.

-Use broad physical action (and don't feel like you can't change positions during scenes).

-Don't wait until the players are in a funny position so you can do the Twister joke.

Hall of Presidents

[This is a scene that takes you on a tour of a blue-collar occupation through the ages. Often it is led by a former President.]

-The Host can set up elements of each different character.

-Characters can be robots, holograms, actors, etc.

-Characters can give monologues, or act out scenes.

Hot Potato (Musical Chairs)

[As players are eliminated in hot potato or musical chairs, they must sing a song in a random style, based on a topic from the audience.]

-Play up the potato toss/chair circling… it's part of the game.

-Teammates (even ones that sang already) should back up the singer.

-Don't feel like you have to rhyme, if you can't think of a good one.

Hyperlink

[During a scene, the MC turns the last line of dialogue into a new scene based on the line.]

-Set up the Caller with lines that could be hyperlinks to new things.

-Clear the stage when the Caller yells a new link.

-Vary the links: some can be scenes, some more web-related.

-If there is a Refresh, do something new (the site has been updated).

-"Home" is the first scene you did (the one based on the suggestion).

-"Back" is the last scene you just did.

-If the Caller yells ".org", ".mil", ".edu", let your scene reflect it.

It Could Happen

[A list of events and social occasions is matched up with a list of characters, celebrities and historical figures. Short scenes about several pairings are performed.]

-You can lead up to the situation (e.g. Cleopatra at the fall of the Berlin Wall… it can start without Cleo, or with her. Vary it.)

-Leave the best ones for last. Get the lame ones out of the way first.

-Really sell the concept. Act like it's supposed to make sense.

Jam

[A song, or series of songs on one or more subjects, often using different styles of music.]
-You can do three songs on one subject, one song on one subject, three songs on three subjects, or one song on three subjects.
-Players can choose their own style of music (or get them from audience).
-You don't have to rhyme when singing.

Late For Work

[A naïve scene where one player explains to the boss why he's late for work, based on physical clues he's given by other players behind the boss's back.]
-When incorporating the suggestions into your "lie", make the story action-oriented.
-The Boss should sum up the lie before bringing in the late player, hitting the main points.
-The Late player should justify wrong guesses and elements of the corroboration.

Laugh Out

[A scene presented like it's supposed to be serious or a melodrama. Any player who gets a laugh is called out.]
-It isn't really a serious scene… it is overly serious. Everything is WAY TOO serious.
-Nothing even remotely "wacky" should occur in the scene.

Limerick

[Players make-up limericks, line by line. This is usually an elimination game, and you are called out when you can't rhyme. Sometimes this is a conducted game, like Story.]
-duh-DAH-DAH duh-DAH-DAH duh-DAH (A)
-duh-DAH-DAH duh-DAH-DAH duh-DAH (rhyme A)
-duh-DAH-DAH duh-DAH (B)
-duh-DAH-DAH duh-DAH (rhyme B)
-duh-DAH-DAH duh-DAH-DAH duh-DAH (rhyme A again).

Madrigal

[Players stand in a line and present a madrigal-like song, using lines from the audience as their lyrics. During the course of the song, players incorporate portions of each other's lines into their own lyrics. This is often conducted like Emotional Symphony or Story.]
-Vary your musical rhythm and style from the other players.
-Start with simple changes in your repeated line.
-Use the funnier variations of the line later in the Madrigal.
-Follow the conduction, repeating whatever line indicated for the finale.

Mega Replay

[A scene that is replayed by two different groups of players in varying styles (see Replay).]
-Save the good styles for the end.
-Contrast the style that just went. Don't do two literary styles in a row, etc.
-Keep the initial scene short, but have a plot and action. Get in there too!

Moving Bodies

[Performers do a scene where they can't move their bodies. Another person (not in the scene) moves their bodies like a marionette.]

-As the Mover, try to make characters face each other (see below).
-As a speaker, try to be aware of when others want to talk.
-Mover should be constantly adjusting actors and moving them around.
-Speakers do NOT have to fall over if they are moved haphazardly (do it if you wanna).

Naïve Replay
[One or more performers are not present while others do a short scene as if they were present. The scene is replayed as closely as possible with the naïve players trying to insert themselves.]
-Set up players shouldn't answer questions the Naïve person can't know to ask.
-Avoid reacting to things physically the Naïve person wouldn't know to do.
-Use your body language to indicate where and what the Naïve person is doing.
-It is all right to tell the Naïve person to start off stage or on stage.

New Choice (Should Have Said/What)
[During a scene, an MC forces performers to take back something they say and present a new, and often radically different line of dialogue.]
-Make every statement a possible offer for the Caller to call New Choice.
-Keep your initial offers relatively mundane (see next item).
-New Choices should get more and more non sequitur (per instance).

Object Tag
[Players use objects collected from the audience in short punch-line scenes.]
-Try not to use the object the way it was intended to be used.
-Avoid doing the stock shtick until there is nothing else happening (Mr. T, Geordi LaForge, Beam me up, Scotty, etc).
-Don't break the objects… they probably don't belong to your troupe.

Opera
[A musical scene presented as an opera.]
-Make the singing big and operatic, not cute and Musical Comedy in its presentation.
-Move the story along. You can have a Deus ex Machina at the end (Gods fix it all).
-Don't worry about trying to rhyme everything you sing.

Parallel Universe
[Performers rotate through three (or more) completely separate and unrelated scenes when an MC switches their settings (from a list compiled before the game starts).]
-Establish things as quickly as possible (you may not have time later).
-Justify positions when you change universe.
-Maintain eye contact, so you know if someone else is about to speak.
-Remember what already has occurred in a particular universe. Build on it.

Pavlov
[A scene where each player is triggered to do something strange by some action or offer of another player.]
-Start the scene with someone who either triggers you, or is triggered by you.
-Avoid getting everyone in the scene too early.

-If you transition, remember to start the next segment with triggering people.
-Once you figure out what triggers someone, use it wisely, sharing focus.
-Justify your Pavlovian reaction, if possible.

Playwright
[A scene that is interrupted by an MC who asks the audience for certain details (who enters next, what is in her pocket, what is his big secret?).]
-Set up the MC with things that can be made into audience input.
-Really sell whatever the audience yells out. Act like it makes sense to the scene.
-Remember to have your scene be about something.

Replay
[Performers do a short scene, and then replay that scene in various styles (movies, theater, music, etc.)]
-Remember that the set up scene is supposed to be one minute. Don't dally.
-Choose the style you think you'll do best as your last one.
-Use every convention you can for each style, rather than everyone doing the same.

Rotation Rap
[An elimination rap that has two performers rapping against each other at a time. When one is eliminated, another replaces him. Set up-rhyme, just like Elimination Rap.]
-Don't start with the weakest rappers. Make them go second.
-The rap tempo can be the same as it is for Beastie Rap, and you can even start by saying "I know this guy and his name is *blank*" (to get you on the right track).
-The beat should get faster with each round, or during a round that is going on for awhile.

Scene in Reverse
[A scene that starts with the last line of dialogue, and the proceeds line by line and in action backwards to the first line of a scene.]
-Go slowly. Take a moment to think of a logical line to "precede" the one just spoken.
-Only ask a question if someone else has just answered one.
-When you enter, make a departing statement. Before you leave, make an arriving one.

Shakespeare
[A scene performed in the language and style of a Shakespearean play.]
-Use 15 words to say something you'd normally use only 5 words to say.
-Don't tack "eth" onto the end of every word.
-Use Thee, Thou, Thy instead of You, Your.
-Use Shakespearean plot elements: Disguises, Poison, Secret Marriage, Plotting, Twins.

Sideline Debate/Insults/Sermon/etc.
[A naïve game where two performers are trying to guess a series of multi-syllabic words (usually an adjective, noun, and verb) from physical clues by their fellow performers. Each guesser gets 15-20 seconds at a time to guess as they are debating the pros and cons of the topic they don't actually know yet.]
-As the speaker, look at your clue givers at all times.
-Speakers should *initially* focus on the speech rather than sounding out clues.

-Clues should consist of a series of short words, that get strung together at the end.
-Speakers should repeat the words they already guessed, so they remember them.
-Speakers should listen to clues from the other team when not speaking.
-Clue givers should never make any sounds or speak.

Sing it!
[A scene where performers break into song after an MC hears a line of dialogue that sounds like a song title.]
-The first line of your song is often the "sing it" line.
-Move the story along in your song (if you can).
-Make statements that the Caller can turn into "sing it" opportunities.
-You can dance and do choreography during songs.

Sit, Stand, Kneel, Bend, Lie Down, etc.
[A scene where no two players can occupy the same physical position (from those listed in this game's title.]
-Quickly change positions if someone is in yours.
-Make the scene be about something, and keep it going.
-Avoid having everyone in the scene too early.
-Purposely change positions if no one else is doing it.
-Justify your new position.

Slideshow (Power Point)
[A player narrates a slide show, and the other performers pose while the lights are down. When the lights come up, the players freeze, and the narrator justifies the tableau in the context of the presentation.]
-People on stage should keep moving until the lights come up.
-The Speaker should try to justify the scene on stage with each slide.
-The Speaker should also be telling a story with the slides.

Slow Mo (Olympics)
[A competition between performers involving a household chore, presented in slow motion, with color commentary by other performers.]
-Do the activity. If it is Ironing, then iron.
-Keep things in slow motion, and don't worry about making sounds.
-Announcers should comment on what is happening, as well as just talking.
-Avoid the "unsportsmanlike" conduct as long as possible. It doesn't have to come to that.

Soap Opera
[Either a spoof of a soap opera, or two separate and alternating melodramatic scenes that switch at a sting from an organ (and everyone pauses dramatically), and ultimately come together as one scene.]
-Use the soap convention... big melodramatic characters, mildly preposterous situations.
-At the Organ Sting, look out at the audience with a surprised look (or eyebrow cocked)
-The opposing scenes shouldn't come together too quickly (or reference each other too soon).

Spelling Bee

[Performers stand in a line and spell words from the audience, one letter at a time. They can then use the word in a sentence, define it, give a quote with it, etc. (also one word at a time, like Dr. Know-it-all).]

-Don't *try* to misspell the word (at least not the first couple of words)
-Spell AS FAST AS YOU CAN (this will take care of the above statement)
-Be a character (a kid, or an idiot, or an idiot kid, or whatever).
-Vary the structure of your sentences/definitions/whatever-using-the-words.

Spit Take

[Everyone in the scene has a cup of water, which they constantly drink from. Periodically players spit their water in "surprise", and justify why they did a spit take.]

-The "spit takes" should start very slowly. Two in a row is too soon in the first half of the game.
-Justify every spit take.
-There should still be a scene going on there somewhere toward the end.

Story

[Performers stand in a line and tell a story. They only speak when pointed to by an MC. When someone messes up, they are eliminated.]

-Don't say "decided to..." Characters don't decide to do it; they just do it.
-Finish a word that someone else starts (especially last letters that they drop).
-Limit the number of characters to no more than the number of players.
-Watch the Conductor at all times.

Switch Freeze

[Two person freeze scenes that are given topics from the audience. An MC calls freeze, and rotates a different performer into the next scene, who then takes on the position of the departing player.]

-Keep the scenes active, so there are new positions to freeze in.
-The MC is the one calling "freeze".
-Every scene has a suggestion (or uses the last one in a new way).

Switch Interview

[Performers rotate in and out of two person vignettes of talk show highlights, ala Oprah, Jerry Springer, Colbert, etc.]

-Remember, this is a talk show, not a date/meeting/train/prison.
-Give the new person the first opportunity to talk.
-Choose big characters, but not the same as the other person.

Tabloid

[Get a random headline from an actual tabloid, and perform a scene about it. Or, get a made-up headline from the audience.]

-You can build your scene leading up to the headline, rather than starting with it.
-Use strong characters, and feel free to use elements of other Tabloid conventions.

Timeline

[After getting an event from an audience member, the performers show various points in that person's life, and how the event was affected by it, or things that influenced that event's occurrence.]
-Start your scene by showing the event (ala Day in the Life).
-Relate all of your time changes to the event in some way (even Jurassic era things).
-Take turns with other players calling out times in the Timeline.
-Change the time, even if you have nothing, if one time has gone on long enough.
-Show us things that lead to the event, and the aftermath of the event.

Town Meeting

[Performers mingle with audience members, and represent the citizens of a town discussing the pros and cons of some mundane or unusual topic, town hall style.]
-Everyone should have big, contrasting characters (even the moderator).
-Try to involve the people around you when speaking out at the meeting.
-One team should be FOR and the other AGAINST the topic. Take turns talking.

What Are You Doing?

[A performer does a physical action, and then is asked by another performer "What are you doing?" The first performer must state something they are clearly not doing, which is now physically presented by the second performer. Go back and forth as long as you can.][23]
-Don't say "I'm…"
-Do something physical as well as verbal (or sound effects).
-Keep doing the activity while you are saying something different.
-Give the other person a chance to do the activity before asking them WAYD?

World without the Letter __

[Performers do a scene where they aren't allowed to say any word containing a letter they get from the audience.]
-At first, just work on the scene. Later on, focus on not messing up.
-Avoid resorting to Yoda speak (at least too early).
-Other characters CAN enter the scene (especially if one team should take a dive).

World's Worst (Foot in Mouth)

[Jump out game where performers get situations, occupations, household goods, and then present the world's worst example of what to say in that situation; worst person in that job; worst slogan for that product.]
-Know beforehand if you're doing a family show.
-Use big characters or a lot of energy if you don't have a killer "zinger".
-I used the word "zinger" up there.

[23] There is some debate about whether or not you stop doing the activity when you say what it is you "are doing". This game started out as an exercise, and doing one thing while saying another thing was one of the points of the exercise. Does this make the game harder? Sure. Now, if anyone ever asks "Where is it written that you're supposed to do it this way?" you can say "In *Short Form Improv* by Jack Reda."

Appendix B

Improv Terms (as I use them)

Bail - Giving up on a scene, hook, or offer when you run out of steam.

Beat - A segment in a scene where something important happens.

Blue - Improv that involves profanity and adult themes (like f@#king).

Canadian Cross - Entering a scene to add flavor, environment, or a one-liner (usually followed by an immediate exit).

Commenting - This is when you say something in a scene that is actually a comment to the audience about something that just happened, or your opinion as a performer about anything in the show. Sometimes very funny. Sometimes a pain in the ass.

Denial - When you do not accept or support an offer, or outright contradict it.

Endow - Making an offer that gives an attribute (endow someone as being old, or endow a location as being hot).

Focus- Whatever the audience should be paying attention to (for the sake of the scene). Stealing Focus would be doing something that is distracting from what's really important.

Game - Something you do in short form improv that is more than just simply an improvised scene (sometimes not even a scene at all).

Gibberish - A verbal device you use, wherein you make up a language that doesn't exist. Sometimes you can slip in real (or real sounding) words like "Bon Jovi", "Häagen-Dazs®", or "Sloppycock", and the audience might not even notice.

In Your Head - Second-guessing your choices or offers, or worrying too much about a note, improv tenet, or potential audience reaction.

Jump-out Game - A non-scene improv game, like 185, that involves punchlines, puns, sight-gags, and Arnold Schwarzeneggar impressions.

Justify - Making sense of something that may otherwise seem incongruous to a scene.

Naïve - Any kind of scene or game that involves one or more players who don't know certain information, and must figure it out.

Offer - Something you say or do in a scene (usually something that is or can be useful to the scene, though not necessarily so).

Pimping - Really pulling out all of the stops for something (usually a genre or a gimmick). Doing whatever it is that keeps getting the laughs.

Rex Harrisoning - Talking through a song, rather than trying to sing actual notes. A good technique to try if you are convinced your singing voice sucks. Named for the actor from *My Fair Lady* and other musicals who wasn't much of a singer.

Sell It - Acting like you meant to do that. Especially important in pun-based games when you know your offers are lame.

Stake - The consequence or plot hook that drives a scene. Raising the stakes would be upping the ante or cascading a problem.

Stock - Something that you did or said once before (and it worked), and you pull it out again. Stock Bits and Stock Characters are the most common forms.

Structure - Deciding ahead of time how a scene or game (or portions of it) will unfold in its beats, plot, or chronology. This does not typically involve pre-arranged dialogue (but can).

Steamrolling - Making all of the decisions in a scene, establishing everything, and endowing everyone. Also called Railroading, or Being a Dick.

130

Suggestion - The topic, theme, or input you get from the audience. The improv is based on the suggestion, or inspired by it in some way.

Trigger - Something that someone (performer, audience, object) does that elicits a specific response. A Meta-Trigger would be a trigger whose response is a trigger for something else.

Waffle - A stall tactic designed to give you time to come up with something. Usually it's excessive and pointless dialogue.

Yes And - The idea of accepting an offer and supporting it. It also means acknowledging the offer and intending to give it focus. Also a feature-length mockumentary about improv, now on DVD.[24]

Of course, there are other terms out there, and some people will use the above terms differently (or correctly). This list is mostly useful if you are ever talking to *me* about improv.

[24] Shameless plug. Get the DVD here: http://www.filmbaby.com/films/713

Appendix C

Tips on Common Themes in Common Musical Styles

Alternative Rock - Angst. "You don't understand me." Effects of heroine.

Blues - Why your baby left you. Being down for so long, and the ramifications.

Celtic - Irish and/or Scottish history and mythology.

Country - The miserable state of your life. Why your wife ran off with your best friend, taking your pick-up and dog with her.

Disco - The fever of whatever. Dancing and celebrating on a Saturday night.

Folk - Peace. Brotherhood. The power and pervasiveness of love.

Jazz - Candlelight romance. Acid Jazz is the same thing, but with a Hip-Hop beat.

Heavy Metal - Somber emotions; fear and anger. Horror. Sexuality. Satan[25].

Hip-Hop - Relationships. Street smarts. Fine-looking people.

Gospel - The word of the Lord, obviously. Retribution, resurrection, redemption.

Lounge - Drunken encounters. Mojo. Nostalgia.

New Age - Soothing environments. Healing.

New Wave - Fetish. Liberation.

[25] Not really. But the perception that Satan is a common theme in Heavy Metal *is* common. You can use that stereotype if you like, or ignore it.

Opera - Seduction, unrequited love. Struggling with disease.

Polka - Eating and drinking. Tradition.

Pop - Love. Boys (or girls). Heartache.

Punk Rock - Aggression. Ambivalence. F@#k society.

Rap - Getting respect. Why me and my crew are better than you. Misogyny. Dangerous lifestyles.

Reggae - The struggles of your people. Going to Zion.

Rock & Roll - Love, sex, drugs, Rock & Roll itself.

Rockabilly - Fast cars, fast women. Rumbles and being cool.

Soul - Rising above your station. Feeling good (regardless of circumstances).

Techno - Dancing. Alternate states of consciousness. Düsseldorf.

World - Anything not associated with the United States.

Zydeco - Loss. Poverty. Gumbo.

Index

Games and terms listed in the Index do not include Appendix entries.

About the Author

Jack Reda has been performing improvised comedy since 1985, when his high school drama teacher introduced him to Theatersports. He has been the director of DCUP (The District of Columbia Unscripted Players) Improv Theater Company, and creator of "Boneless Chicken Cabaret". DCUP won the Battle of the Comedy" at the DC Improv, the DC ComedyFest Sketch and Improv competition, the Miami Improv Festival Best Sketch Show, and a few other less impressive awards. In 2004, Jack directed, starred in, and co-wrote[26] "Yes And", a mockumentary about improv. In 2005, Jack performed with PAX TV's *World Cup Comedy*. He has also performed regularly with ComedySportz in multiple cities.

[26] With Todd Etter, the other founder of DCUP, and a fine human being.

Made in the USA
Monee, IL
24 November 2020